THE
PARCHMAN
ORDEAL

1965 NATCHEZ CIVIL RIGHTS INJUSTICE

G. MARK LaFRANCIS WITH
ROBERT MORGAN AND **DARRELL WHITE**

FOREWORD BY **JAMES MEREDITH,**
WRITER & CIVIL RIGHTS ACTIVIST

THE
History
PRESS

Published by The History Press
Charleston, SC
www.historypress.com

First published 2018

Manufactured in the United States

ISBN 9781467140645

Library of Congress Control Number: 2018948038

To all those from Natchez, Mississippi, who suffered needlessly in October 1965 for standing up for their rights. May this book inspire a new generation to be just as brave.

And to the late Mississippi journalist Bill Minor, who went above and beyond the call of duty to report the truth about Mississippi and especially the civil rights era.

CONTENTS

FOREWORD

F inally!
This book finally exposes one of the least-known, untold travesties of the civil rights era. Most all of us have heard of Bloody Sunday in Selma, Alabama; the Freedom Riders' courage; the assassinations of the Reverend Martin Luther King Jr. and Medgar Evers; the brutal slaying of young Emmett Till; the murders of the Neshoba County Three; and my own struggle with Ole Miss.

However, until now, discussion of the Parchman Ordeal has remained silent on the national scene. You will not read about it in history books nor see it on panels in museums or memorials. Yet the Parchman Ordeal is a scar on Mississippi's history that remained unhealed for a half century. It is my hope that this book will help be a salve to the 150 or so young men and women who unnecessarily endured humiliation, punishment and abuse in October 1965 at the Mississippi State Penitentiary in Parchman, Mississippi. Their "infraction": attempting to walk peacefully in the public streets of Natchez to show their support for equal rights and voting rights.

What? you may ask. No one ever was sent to the state penitentiary for exercising their constitutional rights. In the pages that unfold here, you will witness their arrest outside their Christian churches, the herding of them into the Natchez City Auditorium and the forced busing of them to the penitentiary. There, the ordeal unfolded for days as they were treated, as one of them said, "as less than human."

James Meredith, international civil rights legend.

Also, you will read the extraordinary steps that unfolded before the Parchman Ordeal occurred: the attempted murder of a beloved Natchez NAACP leader; the ruthless attacks of a sinister arm of the Ku Klux Klan and the passionate and reasonable requests of Natchez African Americans of their city government; and the rejection of those appeals.

You will also read about the full breadth of the African American experience in Mississippi: slavery, Reconstruction, Jim Crow, Black Codes, the Sovereignty Commission and the terrible abuse of the Freedom Riders.

Remarkably, the Parchman Ordeal survivors opened their hearts and souls to the authors, exposing the raw and painful experience to which they were subjected as mere teens and young adults. Some of what you read will be uncomfortable, as it should. Yet this book shares their courage, inspiration and strength.

The authors need to be applauded for their passion in telling this story. They have spent hundreds of uncompensated hours on this book and a documentary, *The Parchman Ordeal: The Untold Story*, which has been received with acclaim at national film festivals and was declared the "Most Transformative Film" at the 2017 Crossroads Film Festival in Mississippi. The film also was aired on Mississippi Public Broadcasting.

So be prepared to be amazed, moved and inspired by this most incredible chapter in the civil rights movement…finally told.

Finally!

—James Meredith
Ole Miss, 1962

PREFACE

Natchez: Oldest City on the Mississippi River

Just as the Mississippi River twists and turns, rumbles and surges, zigs and zags, so, too, has the history of its oldest settlement: Natchez. Set high above the river on the Natchez Bluffs, the city has been home to American Indians, the Spanish, French, British, Jews, Catholics, Baptists, Methodists, Presbyterians, Episcopalians, Pentecostals, slaves, free black people, merchants, millionaires, Confederates, Yankees, famous authors, actors, singers, politicians, lawyers, doctors, historians, cotton barons, oil tycoons and gunslingers, all the while perplexing and intriguing visitors from around the world coming and going by riverboats, wagons, cars, foot leather, bus and horseback.

Natchez celebrated its 300th birthday in 2016 with a year full of small and large events. One particular event, though, was very much bittersweet: the Weekend of Reconciliation for the Parchman Ordeal, which is the focus of this book.

Fifty-one years prior to that Weekend of Reconciliation, an event occurred in Natchez that brought hurt and sorrow to approximately 150 young men and women, mostly African American. In October 1965, those young men and women, some as young as fourteen, were taken by law enforcement authorities to the Mississippi State Penitentiary in Parchman, Mississippi, where they were abused, punished and humiliated for days. They did not commit a crime, did not injure anyone, did not disturb the

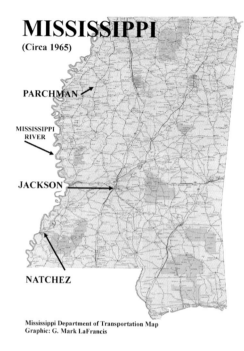

MISSISSIPPI
(Circa 1965)

PARCHMAN

MISSISSIPPI
RIVER

JACKSON

NATCHEZ

Mississippi Department of Transportation Map
Graphic: G. Mark LaFrancis

Left: Map of Mississippi.
*Courtesy Mississippi
Department of Transportation,
authors' graphic.*

Below: Map of downtown
Natchez. *Courtesy City of
Natchez Planning Department,
authors' graphic.*

Downtown Natchez, MS

Natchez City Auditorium

Beulah Baptist Church

Forks of the Road Slave Market

City of Natchez Map
Graphic: G. Mark LaFrancis

peace. The who, what, when, where and even the why will unfold in the coming pages.

These two maps will help give you a sense of place as you journey with the survivors of the Parchman Ordeal.

Thank you,
G. Mark LaFrancis
Robert A. Morgan
Darrell S. White

———————•———————

www.parchmanordeal.org
Facebook: The Parchman Ordeal

Note: As this book was being prepared for publication, the authors requested that the Natchez City Court offer the Natchez civil rights advocates, especially those who survived imprisonment at Parchman, the chance to have their arrests for parading without a permit in October 1965 expunged from city records. Several arrestees accepted the offer, with many more still to be contacted. Thus, the process has begun to right a terrible civil rights injustice.

Part of the proceeds from this book and the documentary The Parchman Ordeal: The Untold Story *will be contributed to the Parchman Ordeal Foundation for projects to educate youth about civil rights and voting rights. The documentary is available at www. parchmanordeal.org or by writing to: The Parchman Ordeal Foundation, 9 Janice Circle, Natchez, MS 39120.*

ACKNOWLEDGEMENTS

Aproject of this magnitude could not have been accomplished without considerable help and support. We are exceedingly thankful to all who had a role in bringing this book to print. We wish to thank Amanda Irle, who was Mississippi acquisitions editor for The History Press, for her patience and advice every step of the journey, and Richelle Putnam, a History Press author, for recommending The History Press and for her technical advice and moral support.

Thank you to James Meredith, civil rights icon, for his extraordinary foreword.

Thank you to those whose scholarly and historical advice was invaluable: Stanley Nelson, editor of the *Concordia [LA] Sentinel*, Pulitzer Prize finalist and courageous author of *Devil's Walking: Klan Murders Along the Mississippi in the 1960s*; James Wiggins, retired history instructor at Copiah-Lincoln Community College in Natchez; Mimi Miller, former director of the Historic Natchez Foundation; historian Ser Seshs Ab Heter-C.M. Boxley, founder of the Forks of the Road Society, for his depth of experience on slavery in the South and particularly in Natchez; Natchez historian David Dreyer; Dr. Angela A. Allen-Bell, associate professor of legal writing and analysis, B.K. Agnihotri Endowed Professor, Southern University Law Center; and Dr. Robert Luckett, director of the Margaret Walker Center and associate professor in the Department of History, Jackson, Mississippi State University, for his extensive counsel to our Parchman Ordeal documentary, the precursor to this book.

Thank you to our sources and resources: William F. Winter, former governor, state of Mississippi; the late Bill Minor, extraordinary journalist; Tommy Ferrell, former Adams County sheriff; Charles Evers, civil rights leader and former field agent, Mississippi NAACP; the President Lyndon B. Johnson Library; *Natchez in Historic Photographs*; First Presbyterian Church in Natchez and the Reverend Joan Gandy; Louisiana State University; the Amistad Collection, Tulane University; filmmaker James William Theres; Natchez National Historical Park; the City of Natchez; the Natchez Literary and Cinema Celebration; the Natchez Museum of African-American History and Culture; the Natchez Association for the Preservation of Afro-American History and Culture; Beulah Baptist Church; Mississippi Humanities Council; the Reverend Clifton Marvel; the Associated Press; the *Natchez Democrat*; Mississippi Department of Archives and History; the William Winter Center for Racial Reconciliation, University of Mississippi; and William Terrell, the *Bluff City Post*.

To our families: your encouragement and support have helped make this book possible.

CHAPTER 1

ORIGINS OF OPPRESSION

Well, once my mother sent me to the store, and as I was walking to the store I saw all the pretty houses, and white people lived in them. And we lived in a little shotgun house, three rooms and bathroom outside....When I got back home I told her, I said, "Mom, why do the white people have so much and all the pretty houses, pretty cars? And we don't have anything?" So, she set me down and she started to explain. She said, "We are from slavery. We came from Africa, the white people brought us over here without us wanting to come and made slaves out of us. And that's why they have everything, because they never were slaves. So, we were once slaves."
—Delores Hence, survivor of the Parchman Ordeal

In Natchez, Mississippi, the oldest settlement on the Mississippi River, sits a patch of land barely an eighth of an acre. The patch is squeezed among a window tinting business, a clothing store, a church and busy streets. Yet it easily could be called one of the most significant patches of land in United States slavery history.

It is called Forks of the Road because at that point two roads in and out of Natchez join and split apart.

There, at that patch, sits a block of concrete. Embedded in that block are chains, gnarled chains, replicating those shackles that were attached to the ankles and wrists of enslaved men and women brought to Natchez by the thousands from eastern states.

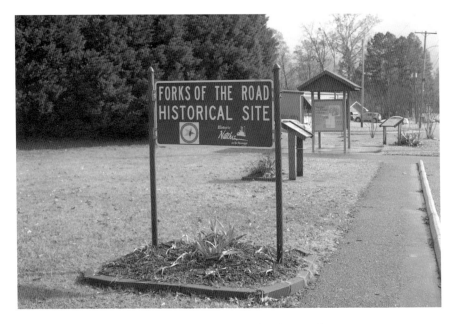

The Forks of the Road in Natchez, Mississippi, a major slave market.

A few explainer kiosks also are part of that Forks of the Road patch. Those stand-alone outdoor kiosks tell a grim story of an era when slavery, not just cotton, was king in the Natchez territory.

"Slavery is central to American history," a kiosk reads. "The labor of enslaved African-Americans built much of the nation's wealth and enabled it to gain its economic independence. The enslavement of people also challenged America's fundamental commitment to freedom. You are standing at the Forks of the Road, the site of several markets where enslaved humans were bought and sold from the 1830s until 1863. This was the center of the trade in Natchez, one of the busiest slave trading towns in the nation."

Another panel states:

> Between 1800 and 1860 more than 750,000 enslaved African-Americans were moved from the upper to the lower South, reflecting a shift in the agricultural economy of each region…
>
> Many enslaved (in the upper South and Central states) resisted being "sold South," fearing break-up of families and harsher working conditions. Some escaped north, some implored neighbors to purchase them, and some even resorted to self-mutilation to make themselves unsalable.

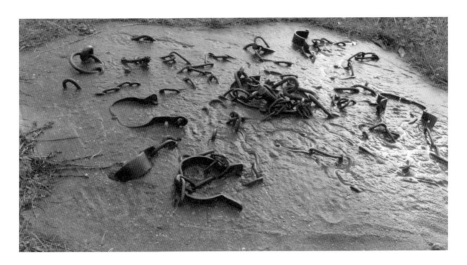

Replica of slave shackles at Forks of the Road.

This is one of the busiest intersections in the city. Thousands of cars pass by each day, as well as school buses, tourist transports and delivery trucks. Many of those vehicles are driven by locals, including many African Americans. It is not inconceivable their ancestors might have stood at that patch while wealthy cotton planters inspected them and dickered over a price.

How this plot of land became so prominent in the slave trade is explained by two notable Mississippi historians, Jim Barnett and H. Clark Burkett, in their story "The Forks of the Road Slave Market at Natchez," published in *Mississippi History Now*, an online publication of the Mississippi Historical Society.

Barnett and Burkett write:

> *In the decades prior to the American Civil War, market places where enslaved Africans were bought and sold could be found in every town of any size in Mississippi. Natchez was unquestionably the state's most active slave trading city.... The 19th century slave trade in Mississippi was linked to the growth of the textile industry in England, which had created a voracious market for cotton by the end of the 18th Century. The invention of the cotton gin in 1793, the advent of the steamboat in 1811, and the introduction of the Mexican variety of cotton into the United States in the 1820s, all helped expand the plantation society in Mississippi after its statehood in 1817.*

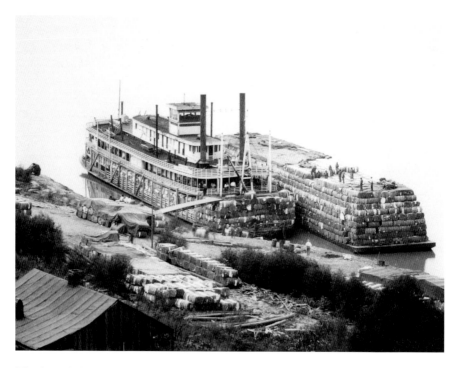

Riverboats laden with cotton bales on the Mississippi River at Natchez Under-the-Hill. *Used with permission from the Norman/Gandy Collection and the First Presbyterian Church, Natchez, Mississippi.*

A placard at the Forks of the Road Slave Market showing Natchez's importance to the slave trade.

Cotton planters in Mississippi and in neighboring states quickly found that slave labor made their business a highly profitable enterprise. Although a federal law passed in 1807 prohibited the further importation of Africans [to America], *a potential slave labor force was already available in the older slave states. Many slaves were living on the century-old tobacco plantations in the Chesapeake Bay area, where agricultural productivity was declining while the slave population increased.*

The importance of the Forks of the Road as a slave market increased dramatically when Isaac Franklin of Tennessee rented property there in 1833. Franklin and his business partner, John Armfield of Virginia, were soon to become the most active slave traders in the United States. Franklin and Armfield were among the first professional slave traders to take advantage of the relatively low prices for slaves in the Virginia-Maryland area, and the profit potential offered by the growing market for slaves in the Deep South.

Armfield managed the firm's slave pen in Alexandria, Virginia, while Franklin established and ran the firm's markets at Natchez and New Orleans. By the 1830s, they were sending more than 1,000 slaves annually from Alexandria to their Natchez and New Orleans markets to help meet the demand for slaves in Mississippi and surrounding states.

Franklin and Armfield sent an annual overland coffle, or slave caravan, from Virginia to their Forks of the Road market. These coffles usually left Alexandria for Natchez in mid- to late summer and traveled through Tennessee. From central Tennessee, the standard route to Natchez and the Forks of the Road was down the Natchez Trace. Entrepreneurial farmers along the route supplied the coffles with pork and corn. During the overland march, male slaves were usually manacled and chained together in double files, and were under the close supervision of mounted drivers. Women also walked, while children and injured slaves rode in the wagons that accompanied the coffle. The white men guarding the coffles were normally armed with both guns and whips.

Franklin and Armfield augmented their movement of slaves overland to the Natchez market by transporting them in ships to New Orleans. The partnership purchased a fleet of steam brigs capable of transporting cargoes of slaves from Virginia around the Florida Peninsula into the Gulf of Mexico. The brigs were capable of steaming up the Mississippi River to the docks at New Orleans. Slaves destined for the Natchez market were transferred to steamboats for the remainder of the trip. The steam brigs, which were equipped to carry between 75 and 150 slaves, normally

A placard at the Forks of the Road Slave Market showing the various routes and methods of travel.

operated between October and May to avoid excessive heat in the tightly packed slave quarters aboard ship.

What is striking when visiting the Forks of the Road and viewing and reading the kiosks is the manner in which slaves were treated, as explained by Barnett and Burkett, as they quote from the narrative of New England writer Joseph Holt Ingraham, who visited the site in 1834:

A mile from Natchez we came to a cluster of rough wooden buildings, in the angle of two roads, in front of which several saddle horses, either tied or held by servants, indicated a place of popular resort. "This is the slave market," said my companion, pointing to a building in the rear; and alighting, we left our horses in charge of a neatly dressed yellow boy belonging to the establishment. Entering through a wide gate into a narrow courtyard, partially enclosed by low buildings, a scene of a novel character was at once presented. A line of negroes...extended in a semicircle around the right side of the yard. There were in all about forty. Each was dressed in the usual uniform of slaves, when in market, consisting of a fashionably shaped, black fur hat, roundabout and trousers of coarse corduroy velvet, precisely such as are worn by Irish laborers,

when they first "come over the water"; good vests, strong shoes, and white cotton shirts, completed their equipment. This dress they lay aside after they are sold, or wear out as soon as may be; for the negro dislikes to retain the indication of his having recently been in the market. With their hats in their hands, which hung down by their sides, they stood perfectly still, and in close order, while some gentlemen were passing from one to another examining for the purpose of buying.

Young black men and women were purchased at this marketplace and then taken to plantations throughout the vast Natchez Territory. Some became cooks, house servants and laborers. Most, though, were bound to their owner's land as field laborers, producing tons of cotton and living in squalor in cotton field shacks.

In his well-researched material, historian Ser Seshs Ab Heter-C.M. Boxley, founder of the Forks of the Road Society, states in his brochure, "The story of Forks of the Road enslavement markets is a story of dehumanization and commoditization of African descendants as prescribed in the America(s) chattel slavery plantation institution of psychological behavioral mind control and conditioning."

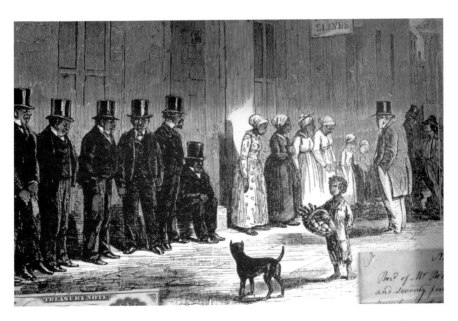

A placard at the Forks of the Road Slave Market showing the dressed-up slaves for sale at Natchez.

Boxley continued, "In his book, *The Black Experience in Natchez 1720–1880*, Professor Ronald L.F. Davis wrote: 'Natchez was a frenzied slave mart literally overrun by professional slave dealers. The essential Natchez experience—possibly even more than the business of cotton—was the buying and selling of slaves.'"

Thus, Forks of the Road is an infamous place where the seeds of this book, this incredible story, take root. To fully understand the significance of the suffering of those exposed to the Parchman Ordeal, we need to experience through oral histories the lives of those exposed to their own ordeal many, many decades before. In *Bullwhip Days: The Slaves Remember: An Oral History*, we see the words of those predecessors. The book, edited by James Mellon, was first published by Avon Books in 1990. It chronicles the exact words of ex-slaves.

Our first "voice" from that oral history is that of Isaac Stier:

> *My ma was Ellen Stier an' my pa was Jordan Stier. Dey masterer was prominent long time ago. I don't 'member much 'bout 'em, an' I don't recall how we passed from folks to folks. Mebbe us was sole.*
>
> *My daddy, he was brought to dis country by a slave dealer from Nashville, Tennessee. Dey traveled all de way on foot, makin' de trib through de Injun' country....When dey got to Natchez, de slaves was put in de pen 'tached to de slave market. It stood at de forks of St. Catherine and Liberty roads. Here dey was fed an' washed an' rubbed down lak racehorses. Den dey was dressed up an' put through de paces dat would show off dey musceles. My daddy was sole as a twelve year old, but he always said he was nigher twenty.*

Our next "voice" is of enslaved Charlie Davenport, who was among the tens of thousands to be marketed at the Forks of the Road. Davenport was sold to a Dutchman, according to his story in *Bullwhip Days*:

> *I was a teasin' miss-chee-vious chile and' de overseer's little gal got it in for me. He was a big, hard-fisted Dutchman bent on gittin' riches. He trained his pasty-faced gal to tattle on us niggers. She got a heap o' folks whipped....One day she hit me wid a stick, an' I th'owed it back at her. 'Bout dat time up walked her pa. He see what I done, but he didn't see what she done to me. But it wouldn' a-made no diff'ence if he had.*
>
> *He snatched me in de air an' toted me to a stump an' laid me 'crost it. I didn't have but one thickness 'twixt me an' daylight. Gent'men! He laid*

on me wid dat stick. I thought I'd die. All the time his mean little girl was a-gloatin' in my misery. I yelled an' prayed to de Lawd till he quit.

Isaac Stier and Charlie Davenport reflected on a time when the enslaved, trapped on plantations and manors, suffered abuse, humiliation and punishment. Oh, yes, historians have documented many instances where the enslaved did not feel the whip or live in squalor in the cotton field shacks. They were enslaved nonetheless.

What is it, then, that causes this book to reflect to that time so long, long ago? In his introduction to *Bullwhip Days*, editor James Mellon says it better than we could:

> *The dominant theme that threads the Gordian theme of these narratives and lends them so much relevance to contemporary America is racism. We ignore this theme at our peril, for no other social problem has cast so long a shadow over our history or cost us so dearly in lives ruined and treasure lost. Indeed, whoever would understand the black community in America today must seek to understand not only the conditions of slavery in which that community was born, but also the experience of racism. For it was racism that gave American slavery its distinctive character.*

Mellon, though, does not include in his analysis an important aspect of the human disparity: wealth versus those who are used to build that wealth. For in the Natchez Territory, accumulation of wealth and the display of it dominated the passions, efforts, plans and lives of the owners of enslaved peoples.

Indeed, their homes, furnishings, clothing, yards, stables and possessions were manufactured symbols of their stature in society and dominance over people, land and commerce. As planters produced the valuable cotton, sold the bales at market and reaped the sales, they needed to show their great wealth: massive homes (constructed using slave labor), hardwood floors, custom wallpapering, large lawns and gardens, art from around the world, mirrors, frames, candlesticks, silver, serving items and more of the highest quality. The wealthy enjoyed balls, musical performances and trips abroad, and their children went to the best schools or had the best private teachers and nannies. Often, trustworthy slaves were employed to watch over the owners' children, and frequently the children and nannies—sometimes called "mammies"—developed strong bonds.

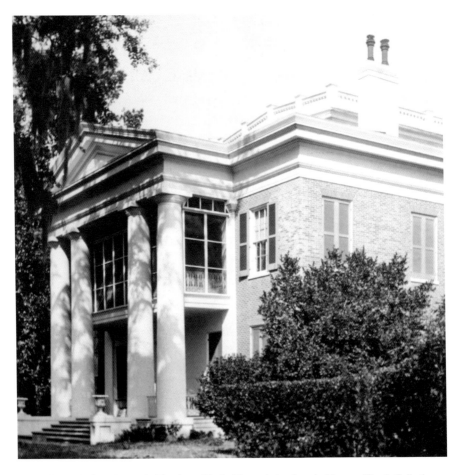

A stately antebellum home in Natchez. *Used with permission from the Norman/Gandy Collection and the First Presbyterian Church, Natchez, Mississippi.*

Natchez wealthy planters often built exquisite houses for their children, who frequently married into the families of other wealthy planters. The intermarriages ensured wealth remained in the families and ensured outsiders would not capitalize on that wealth.

"No place in the antebellum South more nearly epitomized the 'ascendancy' and dominance of the wealthy cotton planter class than the Natchez District, the wealthiest in the Cotton Belt," wrote Aaron D. Anderson in *Builders of a New South: Merchants, Capital and the Remaking of Natchez, 1865–1914.*

Historian Boxley further underscores Anderson's assessment:

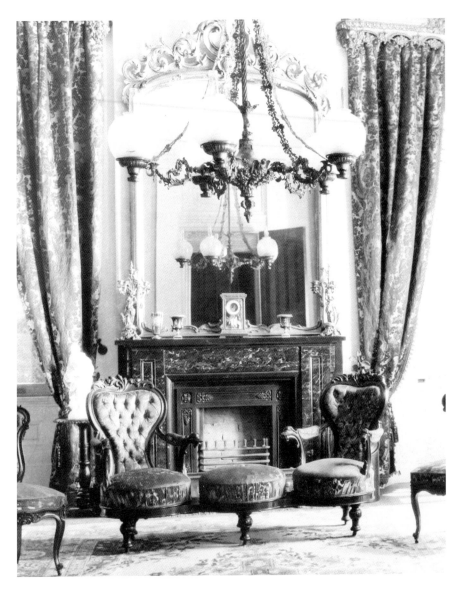

Typical furniture in the parlor of the home of a wealthy Natchez landowner. *Used with permission from the Norman/Gandy Collection and the First Presbyterian Church, Natchez, Mississippi.*

Like no other deep southwest historic site, the Forks of the Roads juncture speaks to America's domestic chattel slavery history of enslavers investing in human commodities and accumulation of wealth and community development produced by enslaved people who were forced—brought in

captivity on the overground railroad routes from the upper to the lower south. Forks of Road speaks to how mothers, fathers, sons, daughters, uncles, aunts, nieces, nephews, cousins and male and female relationships were torn apart just as had been done in the Africa-to-the-Americas trans-Atlantic enslavement trafficking. From the 16th to the 19th centuries, between 10 million and 12 million enslaved Africans were transported across the Atlantic, according to Encyclopedia Britannica (https://www.britannica. com/topic/transatlantic-slave-trade).

The Forks speaks to enslaved peoples' humanity, history, arts, culture and community development contributions denied, omitted and whited-out by racism discrimination, thus, history's other half that must be told here. Forks of the Road speaks to the lower Mississippi Valley presence of and human history of American-Africans and American-Europeans yesterday and today. The Forks speaks to past and present African descendants' humanity, history, spiritual healing power, art, life, music, legacies and community development contributions.

Thus, our opening "voice," Parchman survivor Delores Hence, refers to walking by those houses as a child…wondering not only about them but why she does not live in one of them.

CALL TO ARMS

$1250: For and inconsideration of the sum of twelve hundred fifty dollars, to me in hand paid, I have this day bargained & sold to Francis Surget a certain negro man of black complexion named John and aged about 22 years. I warrant the above described negro be healthy, sensible & sound. Title indisputable and a slave for life.
—Natchez, May 7, 1856, from the brochure Forks of the Roads Enslavement Market, *by historian Ser Seshs Ab Heter-C.M. Boxley*

Without question, the plot of land known as the Forks of the Road in Natchez, Mississippi, can be regarded as one of the most historically significant African American sites in not just the South but the entire nation whose story has yet to be fully appreciated and recognized. Documents referencing the site produced by local, state and national sources are clear in making that point.

In the Forks' heyday, the misery, degradation and humiliation wreaked on the enslaved at that human stockyard seems to be incalculable. Making that statement now in the early stage of our journey in this book is important in understanding the story of the Parchman Ordeal and its importance in the history of the civil rights era, as underscored by this passage in a report by the Natchez National Park Service in its petition for an interpretive center at the Forks of the Road:

Anyone who has a strong appreciation for their struggle for civil rights, this site serves almost as a touchstone. It represents a poignant moment in

history, a beginning point when the rights of African-Americans were at absolute zero. It is representative of the darkest moment that had to pass before the dawn could come. While the connection may not be direct, in a symbolic role the Forks of the Road has meaning and relevance to the entire civil rights struggle. (Panamerican Consultants, Inc., 2007).

But first, a few steps back in history to that tumultuous time: the Emancipation in September 1862. By then, the Civil War was in its second year, and Union forces had become fully ensconced in Natchez, which, unlike its sister city Vicksburg, offered no resistance.

"Freed slaves soon swarmed to Union lines and encampments in Natchez, swelling the local population by thousands, creating a burgeoning refugee problem that overwhelmed occupying Union officials," wrote Aaron D. Anderson in *Builders of a New South: Merchants, Capital, and the Remaking of Natchez, 1865–1914.* Anderson said that the African American women, young and elderly were "loaned out" as workers to various plantations in the Natchez District, particularly those owned by Union sympathizers. Able-bodied men were recruited by the Union army.

So when freedom came for those who were enslaved, waves of blacks left the plantations, emboldened by President Abraham Lincoln's preliminary Emancipation Proclamation in September 1862 announcing that all slaves in rebellious states would be free as of January 1. Recruitment of colored regiments began in full force following the Proclamation in January 1863.

Wikipedia reports:

The United States War Department issued General Order Number 143 on May 22, 1863, establishing the Bureau of Colored Troops to facilitate the recruitment of African-American soldiers to fight for the Union Army. Other people of color who were not of African descent, such as Native Americans, Pacific Islanders, and Asian-Americans also fought under USCT regiments. Regiments, including infantry, cavalry, engineers, light artillery, and heavy artillery units, were recruited from all states of the Union and became known as the United States Colored Troops (USCT).

Approximately 175 regiments comprising more than 178,000 free blacks and freedmen served during the last two years of the war. Their service bolstered the Union war effort at a critical time.

The report continues:

The courage displayed by colored troops during the Civil War played an important role in African-Americans gaining new rights. As the abolitionist Frederick Douglass wrote: "Once let the black man get upon his person the brass letter, U.S., let him get an eagle on his button, and a musket on his shoulder and bullets in his pocket, there is no power on earth that can deny that he has earned the right to citizenship."

From the Civil War Trust, a nonpartisan, nonprofit organization devoted to the preservation of America's hallowed battlegrounds:

The United States Colored Troops (USCT) was the embodiment of Frederick Douglass's belief that "He who would be free must himself strike the blow."…With every engagement they fought in, African-Americans time and again proved their mettle….The USCT was a watershed in African-American history, and one of the first major strides towards equal civil rights.

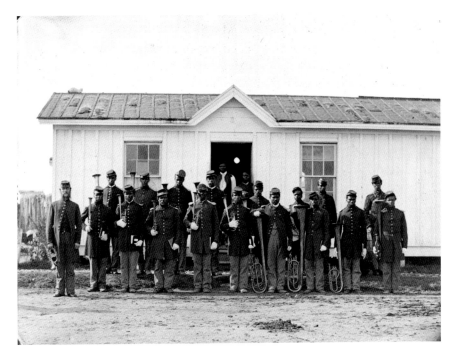

Photo of a unit of the U.S. Colored Troops.

Accurate records are unavailable in the Natchez Territory regarding the number of enslaved who left the plantations; however, local historians believe thousands actually left. Ironically, Union army recruiters established stations at the Forks of the Road and enlisted those emancipated slaves into the United States Colored Troops. The Forks of the Road displays a placard showing several hundred colored troops occupied Natchez during the Civil War. The placard reads:

> *Ex-"Slaves" as U.S. Civil War Soldiers in the Mississippi Valley Campaign*
>
> *In 1863 the United States War Department painted a master stroke with the implementation of the Anaconda Plan which called for the blockading of over 3,400 miles of coastline and control of the Mississippi River. The Plan was successful in its mission to divide Confederate troops and successfully cut off access to precious supplies and communications. Following this President Abraham Lincoln issued the Emancipation Proclamation effective January 1, 1863 declaring freedom only to enslaved peoples in rebel states, counties and parishes.*
>
> *With the successful occupation of Memphis and New Orleans, the Union turned its attention to the capture of Vicksburg, the "key" to controlling the Mississippi. A major component of the Union's success in Vicksburg was the use of thousands of able-bodied ex-"slaves" and the engagement of thousands of Negro women, children and older men. Working as soldiers, and in support roles as spies, cooks, blacksmiths, draymen (wagon drivers), guides and scouts, the runaway and the self-emancipated "slaves" turned the "white man's war" into a war against slavery, showing off self-determination, courage and bravery and the capability to fight well in the heat of battle. In the months of April, May and June of 1863, Mississippi and Louisiana U.S. Colored Troops, as officially designated, fought the Confederates fiercely.*

Southern states provided the lion's share of colored troops. Based on enrollment documents, some 94,000 of the 178,000 colored troops were from Southern states, with Mississippi among the leaders at 18,000. It is uncertain how many of those Mississippi African Americans were from the Natchez Territory, but it's safe to say it was a significant number based on Natchez's prominence in the slave trade.

One of the more famous stories of enlistees in the United States Colored Troops is that of the ancestors of internationally acclaimed African American

Richard Wright, internationally acclaimed author, was a descendant of slaves in Natchez who later joined the United States Colored Troops.

author Richard Wright, who wrote several national bestselling books, including *Uncle Tom's Children*, *Native Son* and *Black Boy*, which is his semi-autobiography.

Wright was born in 1908 in the small village of Cranfield, Mississippi, between the train town of Roxie and Natchez. His parents were sharecroppers, and both sets of his grandparents were slaves. It is believed by family historian Charles Wright that Wright's ancestors passed through the Forks of the Road before being sold to plantation owners in Adams County and plantations nearby.

"When the Civil War broke out, Richard's grandfather (Nathan Wright) returned to the Forks of the Road and enlisted in the U.S. Colored Troops," said Charles Wright. Richard Wright's grandfather returned to the Natchez area after the war and eked out a living as a sharecropper, according to Charles Wright.

Richard Wright was born into that same sharecropping lifestyle; his mother, Ella, educated Richard on Sundays at a small wood-framed church. The family eventually left the plantation and lived for a while in Natchez until his father left the family. Richard, his mother and his brother moved to Jackson, Mississippi, where Richard continued his education in public schools, earning the honor of valedictorian at the Smith Robertson School, then a junior high school. Richard moved to Memphis, Tennessee, then to Chicago, Illinois, and then to New York City. During those years, he earned acclaim with his novels and stories, which sharply addressed the plight of African Americans, often with brutal realism. In 1946, Wright moved to Paris, France, where he died in 1960.

Natchez's role in the contribution made by freed African Americans in the Civil War didn't fade after the war. In the Natchez region, which includes Vidalia, Louisiana, across the Mississippi River, a parade has been held nearly every year on Memorial Day with marchers starting in Vidalia, crossing the Mississippi River Bridge and continuing to the Natchez National Cemetery,

a property of the U.S. Department of Veterans Affairs. The entire route stretches for about four miles, and the march includes veterans, students, bands and just about anyone who wishes to join in.

An award-winning documentary, *The 30th of May*, was produced by veteran James William Theres (Lincoln Penny Films) to commemorate the 150th anniversary of the march. Theres said, "The first known gathering of black soldiers and citizens occurred in 1866. The event was attended by both black and white citizens. Over the next twenty years, gatherings of black and white citizens faded away, and two separate Memorial Day ceremonies emerged. The first known parade happened in 1889 in response, I believe, to white supremacy rising: the monument to the Confederacy in Natchez [in Memorial Park in downtown Natchez] went up in 1890 and of course the [adoption of the] Mississippi Constitution of 1890 [which we will explore later in this book]."

Theres added, "The 30th of May is a significant event in African American remembrance that dates back to the end of the American Civil War. For over 150 years, citizens in Vidalia, Louisiana, and Natchez, Mississippi, have come together on Memorial Day to celebrate freedom and black military service to the country. The tradition is passed down from generation to generation and is relatively unknown outside of the region."

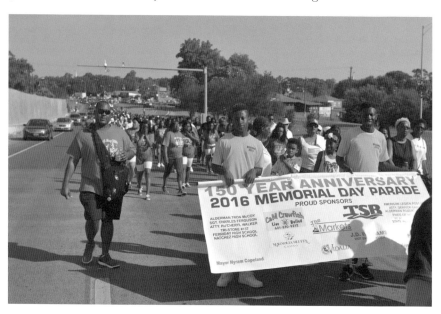

Marchers bear a banner celebrating the 150th anniversary of the 30th of May March. *Courtesy James Theres, director,* The 30th of May.

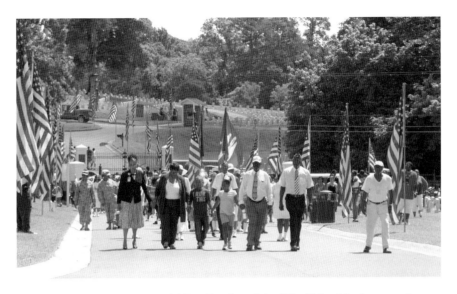

Marchers celebrating the Memorial Day Parade and the 30th of May March process into the Natchez National Cemetery in 2015.

Also each year in Natchez is a festival and reenactment called Black and Blue, commemorating the accomplishments of the U.S. Colored Troops in the Civil War. Local volunteers wear Civil War–era uniforms and march on foot or ride horses at various locations in the city, ending at historic Jefferson College, which was a training center for Confederate soldiers prior to the Civil War. It remained a military school for boys until it closed in 1964. There, reenactors tell the public the stories of courage and sacrifice made by former slaves and free black men to help Union forces win the Civil War.

One of the most ardent and assertive supporters of telling the African American story is historian Ser Seshs Ab Heter-C.M. Boxley, who lives in Natchez and was the backbone behind Black and Blue.

Boxley said:

> *Back in 1995, I announced I was conducting an equal history commemoration campaign aimed at overcoming "white folks making it look like they had done all the community development by themselves," as an eight-year-old African American child once said.*
>
> *The Forks of the Road enslavement market site's history as an equalizer to all the white folks' history and development speaks to what "they" did to us as an African people. Learning about the history and roles of enslaved*

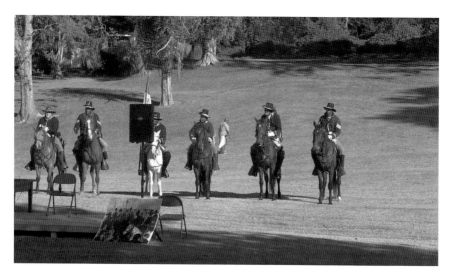

Riders reenact a charge during the annual Black and Blue Festival at historic Jefferson College in Natchez.

and non-enslaved African descendants during the Civil War was initially presented in the movie Glory, *released in 1989. However, it was seeing Sergeant Major Norman Fisher of the First Mississippi U.S. Colored Infantry Regiment Re-enactors protesting the Mississippi Confederate flag on television that spurred my interests in showing and telling stories and history of what I came to call self-emancipated enslaved Union military Freedom Fighters.*

Boxley continued:

I had been observing the annual Natchez Confederate Pageant, where white folks dressed in Confederate period clothing relived chattel slavery days that had gone with the wind.

It seemed like the whole white community was engulfed in the culture and history of Natchez region's chattel slavery days. What stuck out mostly was the number of children who were annually involved in role play in Confederate Pageant that's today called the Tableaux of the Natchez Pilgrimage. It seems as if over dozens of years gone by that just about every young white child had been touched by or was involved in the Confederate Pageant. This made me ask, "What about black children? What do they know about what their great grandparents did as Union Freedom Fighters

to help destroy chattel slavery, gain their freedom and help save the Union of the United States?"

Again as another part of my equal history campaign, I turned to the First Mississippi U.S. Colored Infantry Regiment Re-enactors, led by Sergeant Major Norman Fisher, to gain instant knowledge and information of Union military Civil War Freedom Fighters of Mississippi and Louisiana. This history tells the stories of what enslaved and non-enslaved African descent people did to the enslavers.

As I dove into researching the roles of blacks in the Civil War in the Miss-Lou, I met Nana Bennie McRae Jr., who was the foremost authority and researcher not only about blacks in the Civil War but in U.S. military history. He provided tons of information, reports and history about what I called Union Freedom Fighters. We became friends, and Nana Bennie McRae Jr. provided me with historically accurate and adequate records for us to show and tell the history for educating ourselves and the public of the self-determination and self-emancipation roles, actions and involvement of enslaved and non-enslaved persons during the Civil War and make possible the Thirteenth, Fourteenth and Fifteenth Amendments to the U.S. Constitution.

For years, many historians had steadfastly omitted, hid and whited-out the military roles of runaway enslaved persons serving with the Union. Our Annual Black and Blue Civil War Living History of local blacks in the Civil War equal history commemoration programs overcome these historical white-outs.

In what I call the freedom summer of 1863, when Vicksburg fell to the Union army on July 4 and four days later the Confederates at Port Hudson surrendered to the Union army, thousands of African descendants broke free in ways that showed once and for all they were not content to be held in bondage. Many of these Civil War Union army U.S. Colored Troops and sailors are buried in the many national cemeteries throughout the South. There were some 2,521 U.S. Colored Troops first buried in the establishment of Natchez National Cemetery. Their bodies were removed from the sites of original interment in various localities in Louisiana and Mississippi, within a radius of fifty miles.

Many of the greatest generations of enslaved and non-enslaved Union military freedom fighters were the great grandparents of those twentieth-century local civil rights activists named in the Parchman Ordeal who were part of the struggle in the 1960s to regain civil rights that had been gained in the 1860s.

Thus, the Civil War not only resulted in freedom for hundreds of thousands of former slaves but also gave them the opportunity to battle the Confederacy, which had held them in bondage for two centuries. With Reconstruction about to begin, a sense of new hope for African Americans swept the South and particularly the Natchez Territory.

WE RISE UP

There was a time—Reconstruction in the South, Mississippi and particularly in the Natchez Territory—that helped shape the future of African Americans for more than a century, and this period is still looked back as a golden age for those who had suffered so much in slavery and bondage. If Harlem was considered the capital of black America during the 1920s Renaissance period, then Natchez should be considered the capital of black America during Reconstruction after the Civil War.
—Darrell S. White, director of the Natchez Museum of African American History and Culture

The African American presence in Mississippi grew tremendously in the 1800s, as more and more slaves were imported to feed the ever-increasing demand for cotton, and thus workers were needed to plant and harvest the cotton.

"After a long period of enslavement, the African-American population of Mississippi emerged in 1865 to face the challenges of a new world," wrote Julius E. Thompson in *Lynchings in Mississippi: A History, 1865–1965.* "Blacks had lived in a state that was one of the major cotton-producing areas of the world, with the wealth created going to white people. The black population in Mississippi had grown from 3,454 in 1800 to 437,406 in 1860 or 55.2 percent of the state's total population. The state's free black population in this group consisted of only 773 individuals."

By the spring of 1865, as the Civil War was ending, soldiers began returning home to the Natchez Territory. They were white and black,

Confederate and United States Colored Troops. Natchez, as we previously said, was a Union stronghold, largely because Northerners had developed vast wealth in the community, and Union officers and soldiers protected that wealth, including the extraordinary mansions and the splendid yards and gardens around those houses.

However, while the structures of the houses were saved from the ravages of war, the political, social and economic structures were in a state of rapid change. Many of the former slaves, in need of a job, returned to the plantations, whose fields were in a state of neglect. Plantation owners, devoid of an enslaved workforce, were desperate for field hands. So they created a system called sharecropping. Former slaves could live on and work the owners' lands and share in the harvest. On "paper" the system sounds fair, even benevolent.

In the introduction to "Slavery by Another Name," the Public Broadcasting System states:

> *Sharecropping is a system where the landlord/planter allows a tenant to use the land in exchange for a share of the crop. This encouraged tenants to work to produce the biggest harvest that they could, and ensured they would remain tied to the land and unlikely to leave for other opportunities. In the South, after the Civil War, many black families rented land from white owners and raised cash crops such as cotton, tobacco, and rice. In many cases, the landlords or nearby merchants would lease equipment to the renters, and offer seed, fertilizer, food, and other items on credit until the harvest season. At that time, the tenant and landlord or merchant would settle up, figuring out who owed whom and how much.*
>
> *High interest rates, unpredictable harvests, and unscrupulous landlords and merchants often kept tenant farm families severely indebted, requiring the debt to be carried over until the next year or the next. Laws favoring landowners made it difficult or even illegal for sharecroppers to sell their crops to others besides their landlord, or prevented sharecroppers from moving if they were indebted to their landlord.*

Landowners knew the sharecroppers had little choice: they were poor, uneducated and unskilled, except for the talents they had developed as slaves.

However, that was not the case for all blacks. This was the era of Radical Reconstruction, the attempt by the federal government to change the political landscape of the "rebellious" states and rebuild a new socioeconomic system in the South, one devoid of slavery and one that could not again threaten

the Union. The Congressional Reconstruction Acts of 1867 gave wide latitude to Union district commanders in the South, according to *The Day of the Carpetbagger: Republican Reconstruction in Mississippi* by William C. Harris. Harris writes that in Mississippi, Union general Edward Otho Cresap Ord was empowered by President Andrew Johnson "to protect all persons in their rights of persons and property, to suppress insurrection, disorder, and violence, and to punish, or cause to be punished all disturbers of the public peace and criminals." Further, Harris writes, "In this regard Ord was to register a new electorate, which would include all black male adults, but exclude certain Confederates. Once this process was completed the general had the responsibility for holding elections in Mississippi and Arkansas for delegates to state conventions that would frame constitutions guaranteeing Negro political equality."

Three years later, Harris writes, "the first Legislature in Radical Reconstruction met in Mississippi. Nearly a third of the 106 state representatives and nearly a sixth of senators were African American. At least 226 black Mississippians held public office during Reconstruction. The Legislature ushered in free public schools and had no property requirements to vote. Nationwide, more than 1,500 African Americans served in public office during Reconstruction."

Reconstruction was solidified even further by the passage in 1868 of the Fourteenth Amendment to the U.S. Constitution, guaranteeing equal rights to citizenship and forbidding states from denying those rights, and the Fifteenth Amendment in 1870, guaranteeing all citizens the right to vote, which in that era meant males.

Those amendments, along with General Ord's orders from the president, would have a profound effect on life for Mississippians, black and white, and especially those living in the Natchez Territory, where Reconstruction was particularly successful.

Conflict, though, was soon ahead. Returning Confederate soldiers found their Natchez community relatively intact physically. With farmlands now under the direction of the federal government, those soldiers began to remake postbellum Natchez. Needless to say, the Confederate soldiers didn't take too kindly to those changes and began to take measures to reclaim their dominance over African Americans, as we shall see later.

"Those former Confederate soldiers constituted part of an emerging vanguard of merchant entrepreneurs who would change the face of Natchez and the New South in the coming years," writes Anderson in *Builders of a New South*. "Some were Southern survivors from the antebellum marketplace

as well as Confederate veterans. Joining them were Yankee newcomers or European immigrants."

What resulted was something unique in the South and even the nation: a blended community of whites and free educated and professional blacks who swiftly rose to prominence politically, socially and economically.

"In Reconstruction, Natchez District blacks enjoyed a relatively brief period of real freedom under the protection of occupation [Union] forces," writes Anderson. "They [blacks] held elective offices on the local, state, and even national levels....They voted regularly to further their conditions, and some became prominent landowners. Hiram Revels, the first African-American to serve in the U.S. Senate (1870–1871), owned Sandy Creek plantation; lawyer Louis J. Winston served as Adams County clerk for twenty years and owned Mount Welcome; while the Speaker of the State Assembly John R. Lynch (a former slave), and his brother William owned part if not all of six plantations. Surprising numbers of African-American farmers were able to purchase lesser tracts of lands or smaller plantations."

Revels, a former Union army chaplain and freeman from North Carolina, settled in Natchez in 1866 when he became pastor of Zion Chapel African Methodist Episcopal Church. Revels founded schools for black children. In 1868, Revels was elected a Natchez alderman, and in 1869, he was elected to represent Adams County in the Mississippi State Senate.

Revels's life changed dramatically in January 1870 when he presented the opening prayer of the Mississippi legislature. "That prayer—one of the most impressive and eloquent prayers that had ever been delivered in the [Mississippi] Senate Chamber—made Revels a United States Senator. He made a profound impression upon all who heard him. It impressed those who heard it that Revels was not only a man of great natural ability but that he was also a man of superior attainments," writes John R. Lynch, a political friend of Revels's, in *The Facts of Reconstruction*.

Likewise, Lynch's rise to acclaim could be called nothing less than remarkable. Lynch was born a slave on a plantation across the Mississippi River from Natchez, the son of a white father and mixed-race mother. Lynch's mother and brothers were bought by a wealthy planter who brought them to Natchez. Under Emancipation in 1863, Lynch worked for the Union army and later for a local photographer, according to *Reminiscences of an Active Life: The Autobiography of John Roy Lynch*.

In his autobiography, Lynch spoke of attending night school taught by northerners, becoming active in local politics and being appointed justice

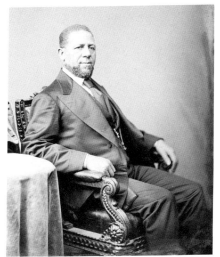 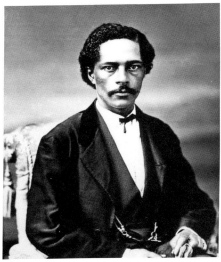

Left: Hiram Revels, Natchez minister who became the first African American U.S. senator.

Right: John R. Lynch, former slave from Natchez who became the first African American Speaker of the Mississippi House of Representatives and later U.S. representative from Mississippi. *Used with permission from the Norman/Gandy Collection and the First Presbyterian Church, Natchez, Mississippi.*

of the peace in Natchez in 1869. The next year, Lynch was elected to the Mississippi State House, and in 1872, he became the first African American elected Speaker of the Mississippi House of Representatives.

In 1872, at the age of twenty-six, he was elected the youngest member of the U.S. House of Representatives at a time when congressional representatives were selected by the Mississippi legislature. Mississippi would not elect another African American congressman until more than a century later.

"In the five-year period (1865–1870), black Mississippians were faced with the tasks of overcoming centuries of the impact of American slavery and of organizing institutions to promote equality, justice and freedom of opportunity for the community in the various spheres of economic, social and political life in the state (and in Natchez)," writes Thompson in *Lynchings in Mississippi.*

Back in Natchez during that same period, black voters elected freed African Americans to public offices from alderman to county supervisor to mayor. Blacks often were seen dressed in finery, eating at the best establishments and frequenting the finest shops.

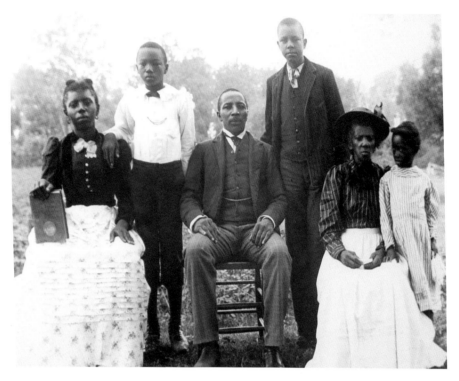

Family portrait indicating a family of means in the Natchez area in the post–Civil War era. *Used with permission from the Norman/Gandy Collection and the First Presbyterian Church, Natchez, Mississippi.*

Natchez had become a community as close as any to the ideal reconstructed southern city. However, forces were at work in the white-dominated Mississippi legislature to erase the postwar gains blacks achieved in Mississippi and particularly in Natchez. Other Confederate states also were at work with similar efforts.

"Too many white Mississippians still viewed blacks as a cheap source of labor," writes Thompson. The first order of business was to regain political control of Mississippi, but it would take whites ten years to achieve this objective. A more immediate task at hand was an expressed need to control the black community. At first, white Mississippians tried to do so with the Black Codes, new laws passed by the Mississippi legislature in late 1865 to control black activity in the state. One study notes:

> *Black people faced serious controls under the code. The law provided for the "binding out" of young black children as apprentices. Former owners*

of the children were given first choice. Blacks had to have a home or job by January 1, 1866, or be fined as vagrants. If they could not pay the fine, they were "hired out," with former owners given the first option. Blacks had to have licenses to do certain jobs; they could not own guns; and they could not rent land except in towns. It was illegal for blacks and whites to marry each other.

The situation for African Americans was only going to get worse.

BEAT DOWN AGAIN

I had a girlfriend, she was practically white, and there was a store called Kress, downtown Natchez. She and I and another girlfriend of mine, we went to Kress, and they had a colored water fountain and then they had the white [fountain]. *So, my girlfriend, who looked white, she was in the colored line. And this white employee came and took her out of the line. She said* [to my friend], *"You're in the wrong line, you drink out of the white fountain." And so, we drank out of the colored fountain, so she just humped her shoulder because she was black. And so we said, "Go on, drink out of the white fountain, you're free, you're free. You can drink out of either one."*
—Delores Hence, Parchman Ordeal survivor

Although the Forks of the Road in Natchez no longer existed for the buying and selling of humans, one fact remained powerful in post–Civil War Mississippi and Natchez: cotton was still king. Growing it, selling it and deriving riches from it were what the plantation owners knew best. And they still needed cheap labor.

Wealth, power and politics merged to assist the plantation owners. Just as the nation in 1870 was ratifying the Fifteenth Amendment to the United States Constitution giving all male citizens the right to vote, southern whites had already begun concocting new methods beyond the Black Codes to stymie African Americans by urging their state legislatures to legalize voting restrictions including poll taxes, literacy tests and property-ownership requirements.

"In essence Mississippi represented the defeated South after the Civil War, and the major goal of the state's white leaders was to maintain order (the older order) and to control black labor and rights," Thompson writes in *Lynchings in Mississippi*. He continues:

> On a daily basis blacks in the state were faced with a system that attempted to use the laws and customs of Mississippi to keep the black community in its historical place. Clearly the Mississippi Black Code, as previously noted, sought to prescribe the freedoms of blacks as Reconstruction opened in the mid-1960s. For many blacks, however, the terror of the times was still focused on such groups as the Ku Klux Klan, a white supremacy organization that, according to scholar Allen W. Trelease, was a major factor in spreading terror and oppression against the black community in the last quarter of the nineteenth century. The greatest criminal justice issue and crisis facing blacks in Mississippi, however, would come with terror associated with lynching and its assorted horrors from the 1860s through the next 100 years.

Anderson writes:

> After occupation ended and Union troops left Natchez in 1877, the position of African-Americans in Mississippi and the Natchez District deteriorated under the attack of those whites who opposed voting and economic rights for African-Americans, culminating during the 1890s in the legal disenfranchisement of all black males. Many hapless African-American share-tenants now found themselves not only locked in a cycle of debt but reduced to second-class citizenship and often the targets of racial hatred.

It is important to emphasize the use of physical violence to keep African Americans "in their place," particularly after the freedoms earned through Emancipation, the Fourteenth and Fifteenth Amendments and the Reconstruction Acts.

David M. Oshinsky describes the plight of African Americans immediately after Emancipation in *Worse Than Slavery*:

> With Emancipation, the focus clearly changed. Violence—and vigilante action—took on a distinctly racial air. The ex-slaves could no longer count on the "protection" that went along with being the master's valuable property. And their new rights and freedoms made them natural targets for

angry, fearful whites. A federal official noted that blacks of Mississippi were now more vulnerable than mules, because the "breaking of the neck of the free negro is nobody's loss."

Now danger was everywhere. Northern senators charged that "two or three black men" were being lynched in Mississippi every day. The true numbers will never be known because local authorities did not bother to investigate nigger killings.

In those years, lynchings often were public spectacles where dozens if not hundreds of whites, and some African Americans, gathered to witness the "stringing up of the Negro."

"In Mississippi, as elsewhere in the South, white men justified lynching in cases of rape 'to protect the white women from the agony of testifying in court.' The evidence from all periods under study, however, reveals that this factor was more in the imagination of the Southern white men than in the actual occurrence of such events," writes Thompson in *Lynchings in Mississippi*.

The following passage reflects the psychological conditions under which African Americans lived for nearly a century after the deliberate destruction of Reconstruction. Thompson writes:

An ongoing united campaign against lynching was put into high gear with the NAACP (National Association for the Advancement of Colored People) playing a leading role. Violence against blacks had increased alarmingly as angry unemployed southern whites took their hostility out on blacks. Anti-lynching legislation was regularly blocked in Congress by southern congressmen's filibusters. Pressed to take action against the barbarism, President Franklin Delano Roosevelt publicly condemned lynching but refused to intervene. He was after all, dependent on the support of southern legislators in the forthcoming elections....

The lynching phenomenon was also used to intimidate black voters and political leaders....Scholars have long noted the violent nature of Mississippi society.

Some scholars point to the economic crisis of the 1870s and especially to the year 1874 to denote tensions and conflicts between blacks and whites in the state. Some poor white Mississippians may have blamed blacks for their own hardships and viewed lynching as one means of receiving the satisfaction for their own general plight in society (i.e. using blacks as scapegoats for white economic turbulence during this period). More upscale whites may have viewed lynching as a method to aid in the control of blacks

as a labor resource on white-owned plantations, farms and other business
to keep blacks on the land, working, and always available for white use.

That assessment refers to the situation for African Americans in the 1860s and years shortly after. However, the violence against African Americans continued for many, many years—even decades.

But lynchings weren't just punishment for crimes—real or imagined—of African Americans against whites. They were far more, as writes Jamelle Bouie, *Slate* chief political correspondent, in 2015:

These lynchings weren't just vigilante punishments or, as the Equal Justice Initiative notes, "celebratory acts of racial control and domination." They were rituals. And specifically, they were rituals of Southern evangelicalism and its then-dogma of purity, literalism, and white supremacy. "Christianity was the primary lens through which most southerners conceptualized and made sense of suffering and death of any sort," writes historian Amy Louise Wood in Lynching and Spectacle: Witnessing Racial Violence in America, 1890–1940. *"It would be inconceivable that they could inflict pain and torment on the bodies of black men without imagining that violence as a religious act, laden with Christian symbolism and significance."*

Bouie adds:

The only Southern Christianity united in its opposition to lynching was that of black Americans, who tried to recontextualize the onslaught as a kind of crucifixion and its victims as martyrs, flipping the script and making blacks the true inheritors of Christian salvation and redemption. It's that last point which should highlight how none of this was intrinsic to Christianity: It was a question of power, and of the need of the powerful to sanctify their actions.

Lynchings and other forms of physical attacks on African Americans weren't the only methods used to intimidate, punish and abuse them. Less than one generation after the Civil War, laws were enacted by majority-white legislatures across the secessionist South to further tamp down African Americans' freedoms.

Mississippi was particularly aggressive in enacting restrictions against African Americans, even to the point of rewriting its constitution in 1890,

creating a system of civil rights oppression, voter suppression and race separation that would last for the next seventy-five years. Unofficially, though, Mississippi's white legislators had begun a decade earlier to plot the overturning of freedoms established in the post–Civil War political era.

So blatant were the restrictions that passed in Mississippi and other secessionist states that the federal government published a pamphlet, *What a Colored Man Should Do to Vote*, found in From Slavery to Freedom: The African-American Pamphlet Collection, 1824–1909 (The Library of Congress).

The introduction to the pamphlet reads: "To the Colored Men of Voting Age in Southern States: As citizens of the United States you cannot value too highly your right to vote, which is an expression of your choice of officers who shall be placed in control of your nearest and dearest interests."

The tome continues: "You should vote at every election. In National and congressional elections vote for the best interests of the country. In local elections vote for the best interests of the community in which you live."

Now, here's the irony—almost tragedy. The pamphlet's pages are filled with nearly impossible requirements for prospective voters (chiefly African Americans) in the former slave states: Alabama, Louisiana, South Carolina, Arkansas, Georgia, Florida, Kentucky, Texas, West Virginia and Mississippi, the latter of which has the most cumbersome restrictions. To register to vote, an individual in Mississippi:

- "Must reside in the State two years and one year in the election district or incorporated town or city.
- "Must have paid all taxes on or before the first day of February of the year of the election, and shall produce his tax receipts to the election officers.
- "Persons under sixty years of age must pay an annual poll tax of two dollars to the State, which may be increased by one dollar by the County." (Based on calculations by the Bureau of Labor Statistics, the two dollars is equivalent to sixty dollars in 2018, or ninety dollars with the county tax added on.)
- "Must be registered, and in order to do so must be able to read any section of the Constitution of the State, or shall be able to understand the same when read, or give a reasonable interpretation thereof." (Keep in mind, education was forbidden for blacks in the enslavement period and nearly nonexistent after Emancipation.)

- "By a decision of the Supreme Court, a person otherwise not qualified has a right to be registered whether his taxes are paid or not.
- "Any person convicted of felony, adultery, larceny, wife-beating or miscegenation (cohabitation among races) is forever barred from voting."

Commonly referred to as Jim Crow laws, these restrictions were implemented with impunity in cities and towns in Mississippi, including Natchez, which had been on the path of establishing a new society far more integrated than most southern cities following the Civil War. *Jim Crow* is a pejorative used to describe African Americans. Other states had their own versions of these Jim Crow laws.

Thus began the era of legalized segregation. For example, water fountains, movie theaters, entrances to professional offices, public employment, schools and much more were segregated. Often, signage clearly marked what was okay for whites and blacks.

Because only black males could vote, black males were the targets of violence meant to intimidate them into not registering and, if they registered, into not voting. Keep in mind, the Black Codes, Jim Crow laws, Ku Klux Klan and other oppressive forces were in full-pressure mode, not to mention

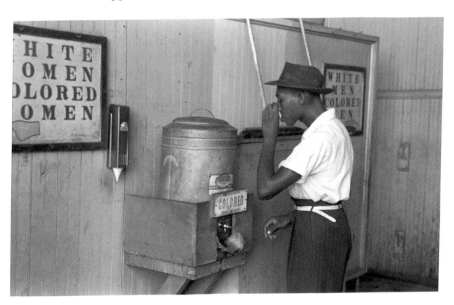

A man drinking from a colored drinking fountain during the Jim Crow era.

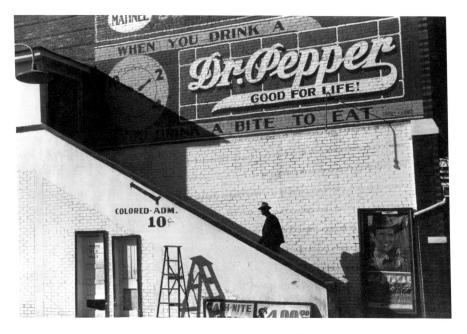

A photo showing a segregated cinema entrance during the Jim Crow era.

the economic and educational constraints under which African Americans tried to eke out a living and education.

Lynchings weren't the only method of choice to intimidate, punish and inflict cruelty. Beating, kidnapping, drowning, tarring-and-feathering, rape, sneers, jeers, illegal arrests and imprisoning and much more were tools used both in public and private. Blacks had little choice but to "mind their place," often with false grins, bows and obedience.

Project that assessment some one hundred years later to the 1960s, and one can see that little had changed for most African Americans, save for the Radical Reconstruction years (1870–90).

But first we need to talk about the African American churches and their role in the lives of African Americans well before the civil rights era.

Because of the rising violence against African Americans, and the vise-like restrictions employed by Jim Crow laws and the State of Mississippi, African Americans increasingly sought refuge in the only place they could call a sanctuary: their church.

"The black church in Mississippi was very active in the 1940s in continuing to promote the spiritual life of the black community," states Thompson in *Lynchings in Mississippi*. He reports that approximately 600,000 African

Americans—slightly more than half of all African Americans in Mississippi in 1944—were churchgoers. "The development extends from the African background through slavery and Emancipation to the present period."

Churches provided economic, spiritual, educational and personal refuge and strength. Wednesday evenings and Sundays were times when spiritual leaders could use the Good Book to give their congregations hope of a "promised land" of equality and prosperity.

Laurei F. Maffly-Kipp, associate professor of religious studies at the University of North Carolina–Chapel Hill, writes in the publication *Documenting the American South*:

> *African-American religion in urban areas of the South also changed dramatically, particularly after the 1880s. Here, issues of class predominated, as middle-class blacks began to build a religious life much like that of their white counterparts: the AME (African Methodist Episcopal) Church, in particular, was noted for its large, formal churches, its educational network of schools and colleges, and its vast publishing arm that included several publications by the end of the century. Black religious leaders became involved in some of the interdenominational institutions, such as the YMCA and the Sunday School movement, that were the bulwarks of evangelical life at the turn of the twentieth century. Yet unlike white evangelical leaders of the day, who were also engaged in theological battles about biblical history and interpretation, middle-class blacks kept their eyes trained toward the basic social injustices wrought by American racism. This battle, which had steadily worsened after the 1870s, promoted a degree of political unity among black Protestant groups that, at times, outweighed their many differences.*

In Natchez, several churches in the heart of the city were especially significant in the lives of African Americans and in the civil rights movement. Among them are Beulah Baptist Church; Rose Hill Baptist Church; Holy Family Catholic Church, the first African American Catholic church in Mississippi; China Grove Baptist Church; and Zion Chapel African Methodist Episcopal Church, where Reverend Hiram Revels, who later became a U.S. senator, once was pastor.

"The church was a standard bearer for black folk, where we could congregate, to fellowship and hear encouraging words from God and the preacher to trust God and be faithful," said Pastor Clifton Marvel of Natchez, past president of the Natchez chapter of the NAACP. Marvel said:

The administration of church affairs gave us a sense of worth in the midst of a society that looked down on black folk and saw them as property and not as human beings.

We could tell our children in the dark days of Jim Crow: "Be careful; watch out for evil men and hold to God's unchanging hand. Just as sure as God freed the children of Israel from slavery in Egypt, He will free us from slavery and tyranny from the white man and Ku Klux Klan."

The church proved to be doubly important during the Civil Rights era: because black folk could have mass meetings and a measure of safety in numbers, to strategize and gain strength in turbulent times.

Freedom fighter Frederick Douglass said, "There can be no freedom without a struggle." To God be the glory for the great things he has done! Amen.

Pastor Clifton Marvel of Natchez, past president of the Natchez chapter of the NAACP.

Because they had the church as the foundation for learning, organizing and strengthening, African Americans knew if change was to come, it fell on their shoulders, young and old, to do something. Next, we will see activism come alive in the African American community in the face of powerful obstacles.

STRIKING THE MATCH
OF ACTIVISM

These [Klansmen] *were not men that were just doing this for something to do, go out and have a few beers. This was serious business to them, they truly felt they were in a fight for the southern way of life for white people and they were out truly to preserve it.*
—*Stanley Nelson, investigative journalist, Pulitzer Prize finalist and author of* Devils Walking: Klan Murders Along the Mississippi in the 1960s

I n the decades after the rewrite of the Mississippi constitution in 1890, great strides were made by white supremacist groups to erase the gains of African Americans during Reconstruction after the Civil War. By controlling who was eligible to register to vote, whites also controlled who was elected to official positions in towns, cities, counties and the state legislature and, therefore, appointments to municipal, county and state jobs.

President Lyndon B. Johnson's impassioned speech to Congress in 1965 in support of the Voting Rights Act clearly addressed the odds against African Americans during the Jim Crow era:

Every American citizen must have an equal right to vote. There is no reason which can excuse the denial of that right. There is no duty which weighs more heavily on us than the duty we have to ensure that right. Yet the harsh fact is that in many places in this country, men and women are kept from voting simply because they are Negroes. Every device of which human ingenuity is capable has been used to deny this right. The Negro citizen may go to register

only to be told that the day is wrong, or the hour is late, or the official in charge is absent. If he [prospective voter] persists, and if he manages to present himself to the registrar, he may be disqualified because he did not spell out his middle name or because he abbreviated a word on the application. If he manages to fill out an application, he is given a test. The registrar is the sole judge of whether he passes this test. He may be asked to recite the entire Constitution, or explain the most complex provisions of State law. Even a college degree cannot be used to prove that he can read and write. For the fact is that the only way to pass these barriers is to show a white skin.

Even with those restrictions many Africans Americans were willing to risk their lives to march for civil rights and voting rights. Such bravery created one of the most powerful movements in American history: the civil rights movement.

Investigative journalist and Pulitzer Prize nominee Stanley Nelson spent fifteen years investigating the activities of the Ku Klux Klan in the Natchez area in the 1960s. His summation: African Americans in Mississippi and the Natchez area were as victimized as they had been one hundred years earlier. It seems phenomenal, almost incomprehensible, but it is true. Nelson wrote in his acclaimed work, *Devils Walking: Klan Murders Along the Mississippi in the 1960s*, that African Americans were just as much targets of white cruelties as they were in the 1860s.

Stanley Nelson, author of *Devils Walking: Klan Murders Along the Mississippi in the 1960s*.

However, African American spirits were lifted by the Reverend Martin Luther King Jr., whose leadership they believed would lead them through the turbulent period endured for three centuries. A Nobel Peace Prize recipient, King was born in 1929 in the Deep South—Atlanta—to the Reverend Martin Luther King Sr. and Alberta Williams King. His was a tough childhood; his father was, by historical accounts, stern and even rough. He felt the sting of segregation and subservience to whites.

But unlike their kin of post-Emancipation, the African Americans of the 1960s were educated, knowledgeable of their rights and determined to effect change even to

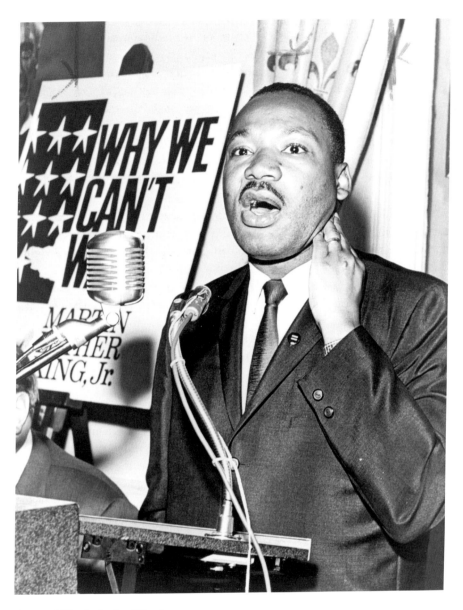

Reverend Martin Luther King Jr.

their deaths, like King. In 1955, ten years before the Parchman Ordeal, King rose to prominence when he helped to organize a 385-day boycott by African Americans of the public bus system in Montgomery, Alabama, after African Americans such as Claudette Colvin and Rosa Parks were arrested for refusing

to give up their seats to white bus riders. The boycott had become a successful tool to fight segregation two years earlier in Baton Rouge, Louisiana, where in 1953 African Americans quit riding public buses for eight days, "staging what historians believe was the first bus boycott of the budding Civil Rights movement," according to a 2003 report on National Public Radio. In 1953, 80 percent of Baton Rouge bus riders were black, so losing their patronage hit city coffers. After eight days of the bus boycott, the Baton Rouge City Council agreed to a compromise that opened all seats except for the front two, which would be for whites, and the back two, for black riders, NPR reported.

King was among several African American leaders who rose to national prominence at a time when African Americans longed for such inspiration. These leaders were orators, organizers and, most important, willing to die. Other civil rights leaders included John Lewis, leader in the Student Nonviolent Coordinating Committee, organizer and later U.S. congressman; James Meredith, Mississippi activist and the first African American to integrate the University of Mississippi; Julian Bond, NAACP chairman and first president of the Southern Poverty Law Center; Andrew Young, Southern Christian Leadership Conference executive director, later mayor of Atlanta and U.S. ambassador; Louis Farrakhan, minister and national representative of the Nation of Islam; Medgar Evers, Mississippi field agent for the NAACP, and his brother Charles Evers, who stepped into Medgar's shoes after Medgar's assassination; Roy Innis, longtime leader of Congress of Racial Equality; Ralph Abernathy, Southern Christian Leadership Conference official; Malcolm X, fiery speaker and activist; Fannie Lou Hamer, co-founder of the National Women's Political Caucus and the Freedom Democratic Party; and Reverend Jesse Jackson, activist. However, it was King who stood atop the ladder of leaders and whose torch was picked up by African Americans nationwide and in Natchez.

"We've been in the mountain of war. We've been in the mountain of violence. We've been in the mountain of hatred long enough. It is necessary to move on now, but only by moving out of this mountain can we move to the promised land of justice and brotherhood and the Kingdom of God. It all boils down to the fact that we must never allow ourselves to become satisfied with unattained goals. We must always maintain a kind of divine discontent," King said in his sermon at Temple Israel in Hollywood in 1965.

Here we begin introducing some of the bravest young people of that era—teens and young adults who, like King, were equally passionate, many of whom eventually became the Parchman Ordeal survivors.

Meet Alfred Smith, whose father was a World War II veteran. Smith was born on December 12, 1951, at Charity Hospital in Natchez. For extra money, he would pick cotton "until dark almost." He said, "We used to pick anywhere between 100 and 125 pounds of cotton after we got out of school."

A slim, lean man, Smith said he wished someday to be a basketball player like Bill Russell or Wilt Chamberlain. Instead, he became a National Park Service worker. Yet in his youth, he knew fear, not freedom, like the others who survived the Parchman Ordeal, although he was among the young people not bused to Parchman prison.

"I witnessed a lot of that when I was young, like going into these different places uptown, like eating places and stuff; we wasn't allowed in there. A café or something that the whites owned, if we were walking we had to go around those [white people]. We just wasn't allowed at those places. We just had to stay there with our own hamburger places and stuff during that time."

Smith said:

I mean it was kind of scary, because when I'd go to the movies my mama would say…she was strict. She'd say, "Y'all be back before dark," so sometimes we would run home because dark was trying to catch us. We would run, my sisters and all of us. We had to make it home before dark. But that's one thing that saved us, by getting home before dark, because

Alfred Smith.

there was a lot of incidents where blacks were attacked and stuff at night, and didn't nobody know who did it. If something happened to a white person and they catch you walking down the street, they'll pick you up and say you did it, put it on you; so that's why we had to be at the house before dark. I know a lot of guys that got caught out like that and they took them to jail.

Indeed, the nation knows of the infamous killings of Emmett Till and the Neshoba Three: Andrew Goodman, Michael Schwerner and James Chaney.

Till was just a teen from Chicago walking down the street in Money, Mississippi, when he was abducted by whites for allegedly whistling at a white woman. Till was brutally murdered in 1955. At Till's funeral services in Chicago, his mother insisted on an open casket to let people see how badly her son had been brutalized. Images in national newspapers of the young man's body in the casket angered many black—and white—Americans, and that event is considered by some historians the spark of the civil rights movement.

Goodman, Schwerner and Chaney were civil rights workers trying to register African Americans to vote in June 1964 during what is commonly referred to as the Freedom Summer. All three were associated with the Council of Federated Organizations (COFO) and the Congress of Racial Equality (CORE).

The three men had traveled from Meridian, Mississippi, to the community of Longdale to talk with congregation members at a church that had been burned. The trio was arrested following a traffic stop outside Philadelphia, Mississippi, for speeding; escorted to the local jail; and held for a number of hours, according to the Public Broadcasting Report "Murder in Mississippi." As the three left town in their car, they were followed by law enforcement and others. Before leaving Neshoba County, their car was pulled over, and all three were abducted, driven to another location and shot at close range. The three men's bodies were then transported to an earthen dam, where they were buried.

According to various media reports and civil rights historians, the disappearance of the three men was initially investigated as a missing person's case. The civil rights workers' burned-out car was found near a swamp three days after their disappearance. An extensive search of the area was conducted by the Federal Bureau of Investigation (FBI), local and state authorities and four hundred United States Navy sailors. The three men's bodies were only discovered two months later thanks to a tip-off. During the

investigation, it emerged that members of the local White Knights of the Ku Klux Klan, the Neshoba County Sheriff's Office and the Philadelphia Police Department were involved in the incident.

Yet in the Natchez area, equally horrific atrocities were committed against African Americans as the Klan created a southern power base in both Natchez and Concordia Parish, Louisiana.

Stanley Nelson recalls:

> *In the winter of '65 when the Natchez NAACP was reorganized and began as an active organization again, the Klan had been watching it very closely. The Armstrong tire plant in Natchez was a real nest of some of the worst Klansmen that there were. In the two years previous, the Klan had sort of gone through this metamorphosis of the traditional Klans like the United Klans of America and the Original Knights and the White Knights, who had had lots of disruptions and leadership problems. And what happened is, in southwest Mississippi and in Concordia Parish, the men that had been among the most active and most violent grew tired of the more traditional Klans. And they sort of gelled into this group known as the Silver Dollar Group, which was formed over in Concordia Parish, which is across the Mississippi River from Natchez.*

Nelson said that in the late 1950s and 1960s, there were two Klans, in a way, in southwest Mississippi and northeast Louisiana. Most belonged to the cross-burning, hood-wearing, marching group. They held power

socially, economically and politically in their communities, and over African Americans. A smaller group composed the bloodthirsty, intimidating and sinister branch of the Klan: the Silver Dollar Group. We will report more about that group later.

Meet Alice Lewis, a Parchman survivor who also was born at Charity Hospital and had a "wonderful childhood...playing with chickens, gathering the eggs" with her nine siblings. She went to church and Sunday school and lived a simple life.

But she learned the sting of racism at an early age.

Alice Lewis.

Once when I was a little girl…I arrived with my big brother in his car, and I had to be, maybe, about ten or nine years old, and I was in his car with him and we stopped uptown. Where he parked, they had these three white men standing on the side, and when my brother got out his car to go take care of his business…one of the white men referred to him as a horse, and I never forget that.

He said, "You can't park there, Horse." So my brother didn't argue with him; he got in his car and he drove away and we went and parked somewhere else, and like I said, I was about nine or ten years old when that happened. Because I understand that they had looked at us as property, and that's what my brother was to him, property, an animal, and I didn't appreciate that. Like I said, I had to be like eight or nine, ten years old, and I felt that.

The word "Horse" was one of the many pejoratives used to describe and address African Americans.

Meet Parchman Ordeal survivor Georgia Mae Sims, second oldest of George and Mary Sims's six children. As a child, Sims went to live with her grandmother, "which was a special joy." A diminutive young lady, Sims attended church with her grandmother, attended local schools and "had a pretty good childhood."

Yet racism was unavoidable.

I remember there was a store here in Natchez…on Franklin and Union…. It was like a five and dime. You could buy a little perfume. Pretty much everything. And that's where a lot of people went to shop. I can remember as a child being with my mother [and grandmother]. We would go into the

Georgia Mae Sims.

store with my grandmother, and they would get their items and get in line. Then this white person would come and get in front of them and get waited on first. I was in school, and I knew that if you're in line, you don't skip. So this was like [when I was] five, seven, eight years old. I was aware then that something wasn't right. Because like I said they taught us you don't skip in the lunch line. You don't skip in any line. If somebody's there, you let them go and then you go your turn. So I noticed then that something wasn't right.

At that time I don't think I was angry. I just knew something wasn't right because they taught us different in school. I know my mama wasn't happy about it because you could tell by her expression that she didn't like it at all.

Another Parchman survivor is Wilford Perkins, who grew up in a neighborhood that he described as the "black Natchez." "It was a strong black community because we took care of our own. We didn't have to want for anything. There was no stealing, no fighting, no nothing because if you did, the people in your neighborhood would whip your butt on your way home, call your mom and tell her and you would get another whipping."

He described his first experience with racism:

It happened one Saturday. I won't forget this because I was at the grocery store with my father, and we were at A&P and we were by the sliding doors. And for some reason, we were in the way of this white guy, and he told us to get out the way. This guy actually kicked me. He actually kicked me on my butt, and I went and told my father about it. My dad and this other guy, they were almost about to fight, and he started using the N word, pretty

Wilford Perkins.

rough, and that's when I found out. Dad just said, "Be careful when you go [out] and where you go." So that's when I really realized that we had a problem here.

And there is Delores Hence, one of ten children whose father died when she was only a month old. She said her mother was told to give up the children. "And she said, 'No, we all gonna starve together.' So my mother raised us the best way she could."

Like the other survivors, Hence learned early on about the differences between blacks and whites:

Well, once my mother sent me to the store, and as I was walking to the store, I saw all the pretty houses and white people lived in them. And we lived in a little shotgun house, three rooms and bathroom outside....But anyway, when I got back home I told her, I said, "Mom, why do the white people have so much and all the pretty houses, pretty cars and we don't have anything?" So she sat me down and she started to explain, she said, "We are from slavery. We came from Africa, the white people brought us over here without us wanting to come and made slaves out of us. And that's why they have everything, because they never been slaves. So, we were once slaves." So I said, "Oh." And I thought I got an understanding from that, until I started growing up and started really, really understanding it.

Delores Hence.

Hence added:

I was walking down the street and there was a sweet shop where I was walking on the side of the street on Pine Street at that time, now Martin Luther King. Someone, as the police was coming by, threw a firecracker out on the sidewalk, and the police jumped out and he got in my face and said that I threw a firecracker. I said, "No, sir, I didn't throw the firecracker." He said, "Yes you did." And I kept saying "No." He said, "Gal, if you keep lying to me I'll put you in this car and take you to jail." And I started crying, and he left me alone. It made me feel so bad, real bad, because I didn't throw the firecracker and I couldn't tell him. He just seemed to accuse me when there was young men and people standing around, but he accused me. I think I was, maybe, eleven or twelve years old.

L.J. Bell is one of the more outspoken Parchman Ordeal survivors. He grew up on a rural farm not far from Natchez.

We grew just about everything that we had to eat. And I was grown before I understood what poverty was. According to standards, we were below the poverty level, but I never looked at myself as being a person of poverty because we had plenty to eat. We raised our own chickens, had eggs and the crazy old cow had milk. We'd grind our own cornmeal and different things that we had. Made syrup. We might not have had what people on a higher level did, but I never went hungry. I wouldn't worry about tomorrow; let tomorrow take care of itself. So that's the kind of life that I was brought up in. And I was raised in a community where black kids and white kids played together. We ate at each other's house. When we had a disagreement, we knocked and fought, and when it was all over, we went back to being kids.

Bell said he enjoyed school, but there was too little of it:

I was a good little worker, and when it came time to plant cotton and everything, it was time for school to start. Well my mama would haul us out of school to work in this man's field, and therefore [that] was throwing us behind. And once the cotton got laid by [planted], then you could go to school. By the time that you get adapted to school, then it's time to pick the cotton. So you've got to come out of school, pick the cotton. The only time you went to school was when it rained.

Bell continued, "But it was whenever I turned fourteen we moved from Lincoln County to Natchez, and that's whenever I got exposed to this race issue."

Combined with the fear of the Klan and local white groups, African Americans had to contend with autocratic white-dominated governments. Yet African Americans, mostly those in their teens and early twenties, chose not to capitulate to the fear but to stand up to it locally, just as Reverend Martin Luther King Jr. was doing nationally.

Delores Young McCullen said:

L.J. Bell.

Delores Young McCullen.

I don't know if I'm allowed to say this, because Natchez was overrun with the Klansmen at the time. All black kids knew about them because I personally had had a couple of run-ins with them. That was a known fact that you could be hurt by them by participating in just about anything. We could walk down the street and we could run into a group of them, and we'd be called names and [asked] why are you here? Go back to Africa and all that kind of stuff like that.

Okay. Martin Luther King was big at the time. It got our attention for civil rights, and we began to learn then what we were missing out as far as our rights were. We were given these rights due to the Constitution, but they weren't being given back to us. I started paying attention and I started listening to the radio and watching TV, and it was like an aha moment. We should have the same kind of enjoyments and the same schools. We shouldn't have to drink out of colored fountains. I just got into it with my parents, and we started going to the church to meetings. As I went, I learned more and more.

Mary Ann Nichols grew up in rural Adams County on a small farm playing with the cows, horses and a goat her grandfather would hitch to a wagon.

"We'd get in that wagon and play with that goat, and I guess one day the goat got tired of pulling us around and he took us down in the bayou. We had to cry and scream and holler to get back out because the goat ran off and left us down in there."

Nichols said, "I had a very good life, loving life. I had godparents that loved me, and I know my mother loved me."

Nichols was raised in the Baptist Church on a rural gravel road before

Mary Ann Nichols.

moving to the "city" of Natchez, where she attended the all-black Brumfield School. African American children walked to school in those days.

The time for the tension when I noticed was something going on, was when I was walking home one day and there was this little Caucasian girl. She would come out and swing on the gate every day and would call us the N word. So I asked my mama, "Why was I called an N word?" And she said it was because of the color of my skin. And I said, "Well, what does that have to do with it?" And she tried to explain to me [racial differences].

Despite the intimidation, segregation and humiliation, young African Americans decided change would come only through activism.

Wilford Perkins recalled:

Yes. It started out, a lot of the big-name reverends used to come to our church, and they would speak on our behalf about voting and stuff like that. We had Mr. Charles Evers, he came in from Fayette, and he spoke at our church one day and told us that we really need to do something about this because it's getting to the point now where blacks are not allowed to do anything. So that got my interest because I wanted to see things better for us as far as not being able to do this and do that and go to certain places and eat, having different kind of water fountains where ours would be all cluttered up and the white drinking fountain was nice and neat but you couldn't drink out of it and it says "colored" and "white," and to this day, I never realized that the racial tension was really bad here in Mississippi, but I said to myself, "If I can, I'm gonna do something. If there's something I can do about it, maybe this is the way. Maybe I can go to these meetings and these marches

and try to voice my opinion on things." That's how I got interested in the marches and stuff, and I was in quite a few, quite a bit.

Indeed, marches occurred with regularity in Natchez. African Americans demonstrated in the hundreds in downtown streets under the watchful eye of local law enforcement authorities and, frequently, members of the KKK. At the same time, events occurred nationally and locally that created the foundation for the brutal and illegal incarceration of the Parchman Ordeal survivors. Both sides of the civil rights and voting rights battle were about to collide.

CHAPTER 6

FED UP

It was time for us to stand up because we were tired.
—Parchman survivor Georgia Mae Sims

On May 17, 1954, an earthquake-size ruling rumbled through the nation, and particularly the Deep South, including Natchez, Mississippi. By a 9–0 decision, the all-white United States Supreme Court ruled in *Brown v. the Board of Education* that state-sponsored public school segregation was unconstitutional. "Special educational facilities are inherently unequal," the court said in its ruling, and it ordered states to desegregate "with all deliberate speed."

For much of the sixty years preceding the *Brown* case, race relations in the United States had been dominated by racial segregation. This policy had been endorsed in 1896 by the United States Supreme Court case of *Plessy v. Ferguson*, which held that as long as the separate facilities for the separate races were equal, segregation did not violate the Fourteenth Amendment ("no State shall…deny to any person…the equal protection of the laws").

Until *Brown v. the Board of Education*, African Americans believed their education was substandard to those of white students, but they were powerless to do anything to change that status.

"The mood of the state of Mississippi for most people, and that is to say white people now, because I was a part of that group, was one of confusion as to how to respond to the Supreme Court decision of 1954, the *Brown* decision, which had the effect of eliminating legal segregation. Segregation

William F. Winter, former Mississippi governor.

was legal up until that time. And so it had become a way of life, not a very good way of life for African Americans and really looking back on it, really not a very good way of life for white people," said William F. Winter, former Mississippi governor, whose political career was devoted to education and racial reconciliation.

Winter's devotion to promoting racial harmony developed during his military service in World War II. Instead of being shipped overseas in the early stages of the war like many of his University of Mississippi (Ole Miss) classmates, Winter was assigned as a training officer to one of the two nearly all–African American training regiments at Fort McClellan in Alabama. The U.S. Army tried an experiment: an integrated officer corps, Winter said.

I found myself soon serving with black officers from all over the country, most of them ROTC [Reserve Officer Training Corps] *graduates and most of them graduates of outstanding universities and even West Point.*

I found them [African American officers] *very impressive people that I soon formed an attachment to and a friendship with and had an appreciation of their abilities and patriotism. So it was wonderful to me. Now let me add being closely associated with African Americans was not a new experience for me. I had grown up on a cotton farm where almost all of the people on the farm were black tenant farmers, so I played with those young people. We hunted together; we fished together; they were among my closest friends. We played baseball together, so I was very comfortable with African Americans.*

Winter readily admits that the African American soldiers had to work harder for recognition than white soldiers and that they came from communities and backgrounds that lacked opportunities for them. Winter, then, developed a unique understanding of both worlds: the white segregationist world in which he was raised and the African American world he experienced as a boy and as a leader of African Americans. So after the

war, as the civil rights era began to unfold, he knew there would be staunch resistance to desegregation.

There was fear. There was confusion. And there was just plain old racial prejudice that was expressed. So there was a defensiveness that proved to be a mechanism by which many white people could seek refuge. The conventional wisdom in the white community among segregationists was that if white people just stuck together, there was no way that the Brown decision could be enforced in Mississippi.

Two organizations grew out of the school desegregation ruling. One was the Citizens' Councils, also called the White Citizens' Councils, a network in the South of white supremacist organizations that resorted to intimidation, fear and violence to attempt to crush civil rights efforts. The other was the Mississippi State Sovereignty Commission, which from 1956 to 1977 was an unofficial investigative arm of the state, profiling tens of thousands of people, mostly African Americans. The commission "collaborated with local white officials of government, police, and business to pressure African Americans to give up activism, especially by economic pressures, such as causing them to be fired, evicted from rental housing, or to have their businesses boycotted," according to Wikipedia. The commission funneled tens of thousands of dollars to the Citizens' Councils, wrote Maryanne Vollers in her book *Ghosts of Mississippi: The Murder of Medgar Evers, the Trials of Byron de la Beckwith, and the Haunting of the New South.* "The agency outwardly extolled racial harmony, but it secretly paid investigators and spies to gather both information and misinformation," according to the Associated Press.

With the commission, Citizens' Councils, Jim Crow laws, white-dominated governments and the Ku Klux Klan, the odds of ever overcoming segregation and achieving equal rights were stacked high against African Americans.

However, events were to unfold in the South and in the Natchez region that changed the course of history. And Natchez was soon to be on the forefront of civil rights activity in the South as the South became a boiling pot of unrest and death. Here are highlights of those events:

- Rosa Parks and the Montgomery bus boycott (1955–57)
- Freedom Riders bus caravan of African Americans and whites protesting segregation throughout the South (1961). Many were subject to beatings and abuse, including imprisonment at the Mississippi State Penitentiary in Parchman

- African American James Meredith being refused to enroll at the University of Mississippi (1962), causing widespread chaos in Oxford, resulting in two deaths and hundreds of injuries
- Alabama governor George Wallace on the steps of the University of Alabama promising segregation "today, tomorrow, and forever" to oppose integration of the university (1963)
- The assassination of civil rights leader Medgar Evers in his driveway in Jackson, Mississippi (1963)
- The March on Washington, where Martin Luther King delivered his famous "I Have a Dream" speech (1963)
- The death of four young African American girls in the Birmingham church bombing (1963)
- The passage of the Twenty-Fourth Amendment to the U.S. Constitution (1964) outlawing the poll tax, which had been used to prevent blacks from voting
- Passage of the Civil Rights Act outlawing racial discrimination in a wide swath of situations, such as employment and schools (1964)
- Mississippi Freedom Summer, during which three voting rights volunteers—Andrew Goodman, James Earl Chaney and Michael Henry Schwerner—were killed in Philadelphia, Mississippi, spearheading a massive FBI investigation (1964)
- Selma to Montgomery March, led by the Reverend Martin Luther King to support black voter registration, resulting in dozens being beaten in Selma, particularly on the Edmund Pettus Bridge, an event referred to as "Black Sunday" (1965)
- Passage of the Voting Rights Act, outlawing voting restrictions, which in the South had been employed almost with impunity (1965)

The bludgeoning of unarmed civil rights advocates by law enforcement authorities on and near the Edmund Pettus Bridge in Selma, Alabama, in 1965 could be called the pivotal moment in the passage of the Voting Rights Act, which at the time was resisted by President Lyndon B. Johnson and Congress. Until then, few in Washington had much stomach for passage, especially considering passage of the Civil Rights Act the previous year. But overwhelming media attention of the beatings on and around the bridge, including horrific photos that were published by news outlets nationwide, forced action by the president and Congress.

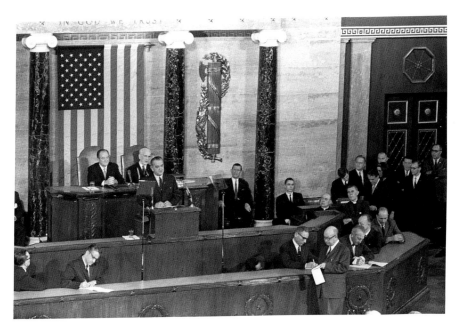

President Lyndon B. Johnson addresses Congress in support of the Voting Rights Act, 1965. *Courtesy Lyndon B. Johnson Library.*

In his address to Congress on March 15, 1965, in support of the Voting Rights Act, President Johnson referred directly to the beatings in Selma:

> *There, long-suffering men and women peacefully protested the denial of their rights as Americans. Many were brutally assaulted. One good man, a man of God, was killed. There is no cause for pride in what has happened in Selma. There is no cause for self-satisfaction in the long denial of equal rights of millions of Americans, but there is cause for hope and for faith in our democracy in what is happening here* [in Congress] *tonight. For the cries of pain and the hymns and protests of oppressed people have summoned into convocation all the majesty of this great government, the government of the greatest nation on earth. Our mission is at once the oldest and the most basic of this country, to right wrong, to do justice, to serve man. In our time we have come to live with moments of great crisis.*

Congress overwhelmingly approved the Voting Rights Act, which the president signed into law on August 6, 1965, outlawing state and local governments from denying any eligible citizen the right to vote. With the stroke of the president's pen, seventy-five years of voter suppression in

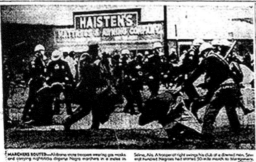

A news story about beatings in Selma, Alabama, on Bloody Sunday.

the Jim Crow states, including Mississippi, seemed to be written away. Mississippi's constitution of 1890 was dealt a deadly blow.

Charles Evers said:

> *Before then, we couldn't vote, couldn't register because you had to tell how many peas in queue and all that silly stuff, how many rocks between here and over there—all this silly stuff* [that registrars required of African Americans]. *Once we got that bill passed, we were free to go and register to vote. And one of the greatest things could happen is that we felt like we made a great step because we also knew that we can start to register and vote.*

Mississippi journalist Bill Minor said:

Mississippi journalist Bill Minor. *Courtesy of Doug Minor.*

Racism in this state is something that is right below the skin level going back to the Civil War. I mean too many people in Mississippi, white people, who are still fighting the Civil War. I mean, they never gave up. And everything that came out of the Civil War, the Black Codes for voting, the poll tax, the registration laws, what they [African Americans] *had to do according to the state constitution was to be able to read and interpret any section of the state constitution that the circuit clerk put in front of them. And the clerk probably didn't even know what it meant himself, but a black came in to be registered and he was handed this constitution provision. And whatever the black man said was gonna be wrong. I mean the circuit clerk would say, "You failed," and "Goodbye." So consequently, it was very difficult to get registered, and that's what made the difference when we finally had the Voting Rights Act pass.*

But not so fast in the Natchez region, which was riddled with attacks on African Americans, most of which were carried out by the Klan and a most violent subset, the Silver Dollar Group.

Investigative journalist Stanley Nelson said:

The Silver Dollar Group began killing [in the early 1960s]; *they had three murders in their pocket before those three civil rights workers* [in Neshoba County] *went missing. The whole epicenter of Klan violence was right here in Concordia* [Parish] *and Natchez. It's where it started. It's where the White Knights burst on the scene in late '63 and early '64. This is where it all began; it started right here, and it's not because the FBI didn't make a determined effort* [to try to apprehend them], *because they did. But these guys were unlike anything they saw anywhere else.*

The Silver Dollar Group, a secret society of white men within the local Klan, was especially violent, even to the point of beating its own members to keep them from revealing the group members' names and activities, Nelson said.

Before we delve into the particular incidents that led to the Parchman Ordeal, it is important to understand the extent of violence and fear

enveloping the Natchez region during the time the nation was convulsing with attacks on African Americans.

Bill Williams, an FBI agent in Natchez for two years during that time, said in a 2005 interview that the "race wars in the [Natchez] area are 'a story never told.'" He said that Natchez in 1964 had become the "focal point for racial, anti–civil rights activity for the state for the next several years," according to a news story by Donna Ladd in the *Jackson Free Press* in 2011, "Evolution of a Man: Lifting the Hood in South Mississippi."

Here are just some of the incidents from our research and the files of Stanley Nelson and the *Concordia Sentinel*:

- July 1964, a short time after the civil rights volunteers were killed in Neshoba County, Mississippi: Joe Edwards, a black employee at a motel in Vidalia, Louisiana (across the Mississippi River from Natchez), went missing and was never found. There were rumors that Edwards was skinned alive and thrown into the river, but the truth was he was abducted by Klansmen and police and run over while attempting to escape along the levee before eventually being killed. His body has never been found. This action was taken because a white receptionist working at the Shamrock Motel in Vidalia, where Edwards worked as a porter, claimed that Edwards had forced a kiss on her.
- July 1964: A soda bottle stuffed with rags soaked in chemicals was thrown at the Natchez home of African American Willie Jackson.
- August 1964: The bodies of Goodman, Chaney and Schwerner were found buried in a dam. The FBI once thought they were dumped into water near Natchez, but those bodies were two nineteen-year-old African American teenagers from Franklin County, Mississippi, who were also murdered by the Klan.
- September 1964: Stink bombs were thrown into the businesses of white mayor John Nosser, who was considered by the Klan to be too supportive of African Americans.
- Approximately September–October 1964: The Mississippi Highway Safety Patrol and FBI agents amassed in Natchez and surrounding areas following several bombings on both sides of the river. The FBI sent agents to Natchez to investigate Klan activities.
- November 1964: Two unarmed African American youths— Henry Dee and Charles Moore—were kidnapped and killed

by Klansmen on May 2, 1964. In July 1964, their bodies were discovered in an old river channel at Davis Island.

- December 1964: African American Frank Morris's shoe shop in Ferriday, Louisiana, was set ablaze by Klansmen. He escaped the blaze but died four days later as a result of his burns. The FBI intensively investigated for years but made no arrests. Several motives were investigated, including that Morris was allowing sexual relationships in the back room of his shop between white women and black men, an allegation the *Concordia Sentinel* disproved. After a multi-year investigation, the *Concordia Sentinel* discovered the true motive: Morris's shop was set ablaze on the orders of notorious Concordia Parish Sheriff's Office deputy Frank DeLaughter, who had argued with Morris over a pair of cowboy boots. The *Sentinel* found documents and witnesses that indicated two Klansmen (Coonie Poissot and Arthur Leonard Spencer) had committed the arson on orders from DeLaughter. In 2010, the *Sentinel* found Spencer, the only participant still living, who admitted he was a Klansman in the 1960s but denied his involvement in the Morris arson. However, Spencer's ex-wife, ex-brother-in-law, son and daughter-in-law individually told the *Sentinel* they were told by either Poissot or Spencer, or both, that the two were involved in the arson. When the *Sentinel* printed this story in January 2011, a grand jury began investigating a month later. Spencer died in 2013.

- August 1965: George Metcalfe was severely wounded in a car bomb at his workplace, Armstrong Tire and Rubber Company in Natchez. The attempted murder is still unsolved but strongly linked to the Klan. Two years later, his friend Wharlest Jackson was murdered with a car bomb near Jackson's home. The Metcalfe bombing was committed by members of the Silver Dollar Group. The *Concordia Sentinel* and *Devils Walking* identified Sonny Taylor of Harrisonburg, Louisiana, as one of the bombers. Taylor became an FBI informant. He admitted to the bureau his involvement, but because Taylor was assisting in other cases, he was not prosecuted. Taylor said the bombing was ordered by Red Glover, head of the Silver Dollar Group.

The attempted murder of George Metcalfe set off a series of events that changed the movement in Natchez, but not until many African Americans had suffered. By that time, large-scale nonviolent marches by African Americans were common, often on the same day as Klan marches. Downtown Natchez became a hotbed of friction to the point several hundred Army National Guard troops were dispatched to patrol the streets.

Fannie Lou Hamer, a civil rights activist famous for her statement to Congress, "I'm sick and tired of being sick and tired," said:

> There's no race in America that's no meeker than the Negro. We're the only race in America that has had babies sold from our breast, which was slavery time. And had mothers sold from their babes. And we're the only race in America that had one man had to march through a mob crew just to go to school, which was James H. Meredith. We don't have anything to be ashamed of. All we have to do is trust God and launch out into the deep. You can pray until you faint, but if you don't get up and try to do something, God is not going to put it in your lap.

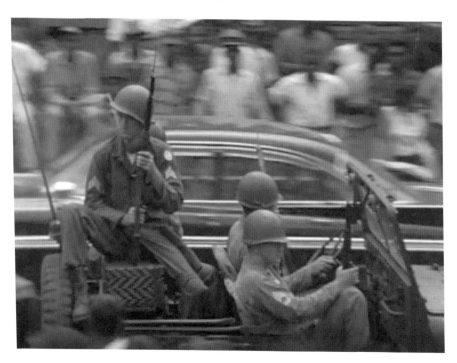

Mississippi Army National Guard units patrol the streets of Natchez during the height of the civil rights movement. *From the film* Black Natchez, *Amistad Collection, Tulane University.*

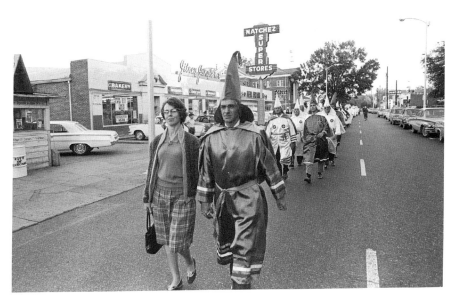

Mississippi Ku Klux Klan Grand Dragon E.L. McDaniel and his wife lead nearly six hundred whites, including over one hundred robed Klansmen, down the streets of Natchez on October 30, 1965, just two hours after one thousand African Americans staged a protest march along the same route. Both groups marched to the Adams County Courthouse. *AP photo. Used with permission.*

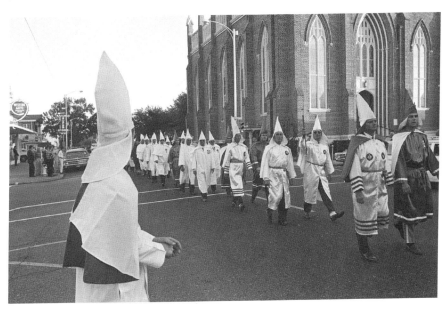

A Ku Klux Klan march down Main Street in Natchez, past St. Mary Basilica, a Roman Catholic church. *AP photo. Used with permission.*

Those thoughts capture the feelings of African Americans in the Natchez area. So fed up were they that African American leaders, following the near-murder of George Metcalfe, submitted petitions to the Natchez city government—the all-white city government.

Parchman survivor Herestine Pike said:

> As I got older, I realized what segregation was about. When you went to the store, if it was a white person ahead of you, you waited. If it took you all day to get waited on, you were the last person they waited on. Then especially when Charles Evers came in [to Natchez], oh man, when I tell you I was into that civil rights, I was in it. We would march across Canal Street. Up and down the streets, I mean at night. We didn't realize that we could have gotten killed. When he [Charles Evers] spoke, he said that things just weren't right and that we needed to change. The most important part was getting to vote. You needed to vote in order to have a voice. That was number one. If you could get everybody to vote, get them registered to vote, then you could make a difference. This was the main thing: get the people in town registered to vote. My momma and daddy told me, "Be careful," that's all. Because my daddy believed that things were supposed to be better. My daddy went to the navy; he got blown up in Pearl Harbor. So I mean he believed that we were supposed to live better, live different.

"I was aware of racial discrimination and what could happen to you. Then like I say, when the civil rights marches started, sit-ins and bus rides and everything, you become aware. I was just a teenager then. Then they [civil rights leaders] came to Natchez, and it was time for us to stand up because we were tired," said Parchman survivor Georgia Mae Sims.

Helen Smith White, a young teenage mother at the time, was eager to become involved:

Helen Smith White.

> All my life it was always that I was [treated as] second or third or fourth or fifth [class]. And that I always had to stand back. I couldn't go this place. I couldn't go that place. I couldn't just walk up in a place and order whatever I want. I couldn't go in a store to buy clothes and

just be waited on right away. I always had to stand back in the corner and wait until someone made up their mind to come and ask me could they help me with something or what did I want. It was an anger, even with me being young, it was anger because I didn't feel like I should be treated like that. I felt like my money may not have been as much as some of the whites' money. But my money was still the same, but I was treated different.

I'll never forget my mom telling me—she always called me Helena. She said, "Helena you make sure you be careful, baby, and you come back since you have your child here to take care of…" I said, "Okay, Mom." I was just happy to be able to do something. I felt like I would be doing something that would really count for my people. For me and for my baby that I had at home, and that he could grow up knowing that I had played a part in getting things better for him.

Alice Lewis was ready for change:

I was a teenager, and we used to all sit around talking about it [the need to march]…and I was gung-ho on it, because I'm used to seeing "colored fountain," "white only," where you couldn't go into the bathroom. You had to stand outside to catch the Greyhound bus. Whites sat inside. I experienced that, and I knew the only way this is gonna change, you got to stand your ground, and that's what I did. I felt this was a beginning of a long struggle, and I was ready for it.

"We were taught that there was a difference in race," said Manuel McCrainey. "For an example, if I would walk down the sidewalk…if a white lady and a young girl would be walking down the [same] sidewalk, I would have to step off the sidewalk and tip my cap or hat, whatever I had on, and let them pass. The girl would be young, much younger than I. I would have to say 'Miss' to her."

Georgia Mae Sims said:

We had been watching TV and stuff with the civil rights movement, what was going on in Mississippi, you know the killing. I remember…I didn't know Emmett Till, but I remember what happened to him back then. There was a paper called the Chicago Democrat *that black people could send for and get. That's how we saw the pictures and stuff of what went on [at that funeral] and what happened to Emmett Till. So I was aware of racial discrimination and what could happen to you.*

Manuel McCrainey.

At the time, Natchez was brimming with tension. Frequently, the streets were packed with demonstrators, civil rights leaders on loudspeakers, Klan marches and African Americans boycotting white-owned businesses, especially those where African Americans were not allowed to shop or were treated badly by store personnel. Frequently, African Americans were picked up and jailed for minor or trumped-up charges. In this super-charged atmosphere, there were a few courageous white leaders willing to stick up for African Americans.

Despite the violence, Forrest A. Johnson Sr., a well-respected white attorney in Natchez, began to speak out and write against the Klan. From 1964 through 1965, he published an alternative weekly newspaper called the *Miss-Lou Observer*, in which he took on the Klan. Klansmen and their supporters conducted an economic boycott against his law practice, nearly ruining him financially.

"Times were hard," said his son Forrest "Al" Johnson Jr., an attorney and circuit judge in Adams County. "Due to his actions, he is in the Mississippi Sovereignty Commission files as a most treacherous white man and selling his rights as a southerner. There were constant death threats, and he was actually shot at by a Klansman in a downtown alley. His church even told him to leave. It was that bad."

Times also were tough for another white lawyer, Leonard Rosenthal, a highly accomplished attorney who worked on cases with nationally known William Kunstler. According to the book *Standing against Dragons: Three Southern Lawyers in an Era of Fear*, "As a result, his landlord evicted him from his office building in Jackson, and one of his relatives became so enraged at

Front page of the *Miss-Lou Observer* on August 11, 1965, with a photo of President Lyndon B. Johnson's hand signing the Voting Rights Act. *Courtesy Forrest "Al" Johnson Jr.*

his association with civil rights attorneys that he chased the young lawyer with a shotgun." Rosenthal relocated to Natchez, where he was a public defender and attorney for many years.

His friend and Judge Eileen M. Maher said of Rosenthal:

> *I once asked Leonard Rosenthal what got him interested in the civil rights movement. He told me he watched as arrestees black and white, all of them young, being taken from the courthouse by law enforcement officers. They were handcuffed. The law enforcement officers kicked their legs out from underneath them and dragged them down the steps by their feet, their heads banging on every step. He said after that, "I had to be involved."*

Yet it was the courageous African Americans in their teens and early twenties who led the charge with brave leaders such as Charles Evers despite the very real likelihood of arrest, physical harm and even death, as we will see next.

GEORGE METCALFE

Here's a receipt of a news bulletin from WNAT [radio]: George Metcalfe, president of the Natchez Chapter of the NAACP, was critically injured in Natchez this afternoon when dynamite hidden beneath the hood of his car exploded when he turned on the ignition. The injured Negro was rushed to Jefferson Davis Memorial Hospital where he was given emergency treatment. Officials at the hospital declined to comment on his condition. Mr. Metcalfe had been active in the voter registration drive in Natchez, and had been the signer of a school integration petition.
—*radio broadcast, August 27, 1965, from the film* Black Natchez

George Metcalfe was born on September 20, 1911, in Franklin, Louisiana. At the time of the bombing, he worked as an employee of Armstrong Tire and Rubber Company in Natchez, Mississippi. He was an active member of the NAACP and served as president of the local chapter in Natchez and treasurer of the local chapter in Jackson, Mississippi. Metcalfe, along with Wharlest Jackson, his friend and fellow NAACP chapter officer, successfully pressured Armstrong to end segregated conditions at the plant, and Armstrong soon began handing out promotions regardless of race.

George Metcalfe, in addition to his work at Armstrong, also led a delegation to the city school board demanding schools desegregate in conformance with the Civil Rights Act and the *Brown v. Board of Education* decision. He submitted a petition to the school board on August 19, 1965, calling for integrated schools. He also included a request not to release the

George Metcalfe, president of the Natchez chapter of the NAACP. *Courtesy Natchez Museum of African American History and Culture.*

names of those who signed the petition. The next day, the names of the petitioners were published in the local newspaper, exposing them to derision, intimidation and targeting by the Klan.

During the 1960s integration efforts, George Metcalfe marched side by side in Mississippi with civil rights leader Medgar Evers, who was assassinated in his driveway in Jackson in June 1963 by a later-convicted Klansman.

On Friday, August 27, 1965, after Metcalfe got into his car at the tire plant to head home from work, he put the key into the ignition and turned the switch. A tremendous explosion rocked the windows of the plant as a bomb ripped his car apart. Miraculously, Metcalfe survived despite extensive injuries. No one has ever been charged in his attempted murder.

This one incident, the attempted murder by bombing of George Metcalfe, became a turning point in the civil rights movement in the Natchez area and possibly the South.

"A slim, quiet man, serious in mind and nature [George] Metcalfe could also be jovial. By 1940, he and his wife Adell, then twenty-seven, were living in Natchez where he drove a truck for a sawmill and she worked as a waitress," wrote Stanley Nelson. Nelson's work in trying to uncover the truth in civil rights cold cases drew him to take a serious look at the Metcalfe attempted murder.

Metcalfe became a marked man chiefly because of his work with COFO (Congress of Federated Organizations), a coalition of major civil rights organizations in Mississippi. Also, Metcalfe helped relaunch the Natchez chapter of the NAACP, buoyed by growing national efforts to pass legislation guaranteeing civil rights and voting rights. As the radio announcement said, Metcalfe signed a petition to integrate the public schools in Adams County and was a plaintiff in a lawsuit to desegregate the schools just days after the Voting Rights Act became the law of the land in August 1965. Indeed, he was a marked man, pushing hard against the principle that blacks needed to "mind their place." By then, Metcalfe was working at Armstrong Tire and Rubber Company in Natchez, a large, sprawling factory occupying nearly two city blocks inside city limits.

Nelson said:

> *Several of the Silver Dollar Group Klansmen worked at the Armstrong Tire plant. And there every day, they would watch Metcalfe come to work and leave work and watch him during lunch breaks and different activities such as that. The Klan hated George Metcalfe because of his civil rights work and because just personally there was just something about Metcalfe*

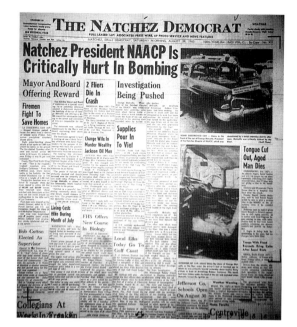

Right: Front page of *The Natchez Democrat*, August 28, 1965, reporting on the attempted assassination of George Metcalfe. *Courtesy the* Natchez Democrat.

Below: The bombed car of George Metcalfe. *AP photo. Used with permission.*

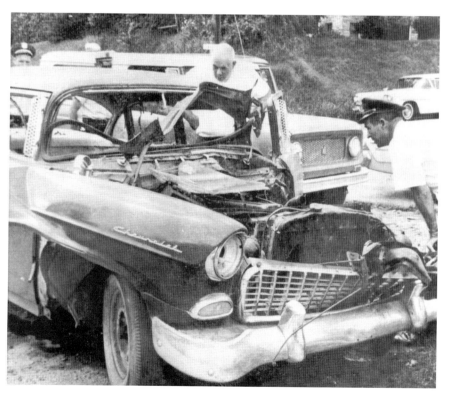

they did not like. The head of the Silver Dollar Group was a man named Red Glover who was a tire builder there at the plant. By the spring of '65, Glover became more and more determined to do something about Metcalfe. In fact, in the FBI documents they would talk about Glover having this passion to kill Metcalfe that could not be quenched. He just absolutely despised Metcalfe.

According to Nelson, Glover handpicked the Silver Dollar Group's members and swore them to secrecy. Their secret identifier and symbol of unity to the group was an actual silver dollar Glover gave to members.

Their belief was this: the politicians could not stop integration, our own Klan leaders and the traditional Klans have done nothing to stop this. We don't believe in them anymore, we don't like the ceremony, we don't care about wearing Klan robes and having meetings and burning crosses. All of those things are silly and ceremonious and simply for public display. They mean nothing. We're in a war, and we have to go against the people that are trying to force integration down our throats because we're not going to have it. Our children are not going to school with black children in our public schools. And if we have to take this battle into our own hands, we are not afraid of the FBI; we're going to do it.

Like the area Klansmen, the Silver Dollar Group members were enmeshed in the community, Nelson said. They were lawyers, police officers, store owners, sheriff's deputies, factory workers, clergy, politicians, mechanics and, well, the folks who ran not just Natchez but also cities and states around the South. Not all whites belonged to the Klan, and in fact, some whites disliked and even hated the Klan and what it stood for.

Now, about the Silver Dollar Group and the attempted murder of George Metcalfe. Nelson said:

Making a bomb is not real easy to do, and then fixing a bomb that can be connected to a vehicle and explode as you want it to do and to do it the way you want it to do takes a little bit of expertise. So I think what to understand is, there are Klansmen, there are men that join the Klan for political reasons who were totally against integration, but they were not violent people. What you had left in many cases were men willing to kill. And they would do anything to do it. They studied about it, they thought about it, they investigated it, they spent time. It wasn't like one day they

were sitting in a bar drinking a beer and [said] *let's go out and do this. It wasn't that way at all with the bombing. Some of the other killings may not have been the initial motive; it may have been to beat somebody up, to run them out of the county, run them out of the parish. To instill fear in them so they would never do whatever it was that offended the Klan....But the bombings were intended to kill. The Klan wanted Metcalfe dead. They had no desire to hurt him; they wanted him dead. And they never got him.*

Nelson added:

Glover would talk about how he wanted to get Metcalfe. He suggested that maybe they just drive by his house one day and just shoot into the house, which somebody did one time, but Metcalfe was not harmed. They would drive by and they would see the civil rights workers there, and it would just drive the Klan crazy, this hardcore group. So one day at a fish fry in Concordia Parish (across the river from Natchez), Glover and two Silver Dollar Group members began hatching the plot to kill Metcalfe.

They were going to kidnap Metcalfe from the tire plant one night after he got off work, and they were going to take him out and kill him. That didn't work. And another day, Glover planned to maybe actually just assassinate Metcalfe there as he walked through the parking lot at the plant, and that was aborted. And at some point in his mind, he settled on a bombing. He wanted something for the public to see; he wanted to put fear into the black community.

After the fish fry, they were totally unsuccessful in getting any of their bombs to work that day. So he had two of his Klansmen who he assigned to experiment, "You figure out a way to make these explosives work when we need them to." And what they did was, they began to experiment with how would you blow up a tree stump just as an object. How do we make it blow up with the use of a car because Metcalfe drove a Chevrolet. So what they had to figure out is how do we make this bomb explode. And about the first thing they thought of was, how do we hook it up so that when the ignition is turned, the car will explode? And that's the premise that they worked on.

And finally one day, around late August, around the time Metcalfe and the NAACP filed the desegregation lawsuit and just a few days after the passage of the Voting Rights Act actually, the two Klansmen, working in Catahoula and Concordia, one day were able to hook that explosive to a tree stump and connect it to the ignition coil of a Chevrolet car very similar to Metcalfe's. And when they turned the switch on that car, that stump

exploded to smithereens. And they tell Glover, "We did it; we know how to do it." And he says, "Okay, let's do it."

And he assigns this one particular Klansman who brings another one with him. They go to the [Armstrong Tire and Rubber Company] *plant; Metcalfe's inside working. They slip up under his car, under the hood; they plant the bomb; they wire it; and they slipped away. And Metcalfe gets off work, and he goes and he turns the ignition, and that car explodes. Blows him out of the car. Shatters off a part of the front of the car, shatters glass. His shoes were laying on the floorboard. How that happened I don't know. But it just shows you the strange power of bombs and what they can do to things and to people.*

Metcalfe of course is taken to the hospital. Nobody thinks he's going to survive at first. The FBI quickly, very quickly, moves in, gets out in the field, find their informants and they begin to sort of see what happened. They have an idea of what went on. Metcalfe in the meantime, they realize that he is going to live, but he's going to have permanent life injuries, but that he will be okay. For the Silver Dollar Group, this was a hugely unbelievable disappointment. Glover was devastated by it, but he wasn't planning on giving up. But what surprised him was instead of that bombing terrifying the black community, it simply inspired them and it led to the marching. It led to the economic boycott, which the Wall Street Journal *later would say was one of the most effective boycotts in the history of the South.*

Back at the NAACP office in Natchez, calls were coming in about the condition of George Metcalfe. The city was teeming with activity, with some African Americans wanting to arm themselves and take revenge.

Charles Evers, then field agent for the Mississippi NAACP, continually called for nonviolence as he stood outside the Natchez NAACP headquarters.

"Y'all are sad today…sad tonight…about this brutal attack on our own," Evers told the throng. "I know all of us are angry. I'm not denying it. We all are tired of being mistreated. We know who is responsible. And we must use the weapons that we are soon going to have to use to get rid of them."

At that point in his speech, the audience, mostly young African Americans, began cheering; some even had weapons.

Evers continued, "The most effective weapon, you know, is the vote." Some in the audience screamed, "No!" In Natchez at the time, there were violent elements of the Klan but also violent elements of the African American community who wished to shed some white blood. Evers calmed them by saying, "We've got to stick together. We've got to listen and be obedient and

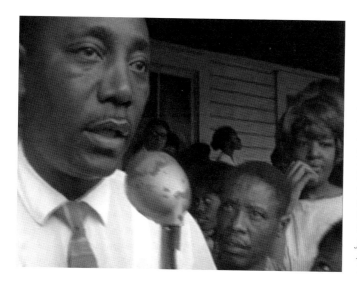

Charles Evers, Mississippi field agent for the NAACP, urges nonviolence while speaking to a group of African Americans outside the Natchez NAACP headquarters after the attempted assassination of George Metcalfe in 1965. *From the film* Black Natchez, *Amistad Collection, Tulane University.*

do what you're told. This is most important. We cannot go off on no wild goose chase. We can't be as ignorant as they have been."

Following the near-death of George Metcalfe, African American leaders gathered in the cafeteria of Holy Family Catholic School, adjacent to Holy Family Catholic Church, both the oldest African American Catholic school and church in Mississippi. Charles Evers was among them, along with the Reverend William Morrissey, a white Catholic priest and civil rights advocate.

Sensing the potential for bloodshed following Metcalfe's near-death, Evers and the leaders developed petitions to the Natchez city government, hoping to achieve some form of racial equality. Evers told the gathering at the school, "Let's not ask for too much. Let's ask for eight or ten things we know we can get. The things that's most precious."

Following is what they asked for, as written and presented to the Natchez mayor and board of aldermen on August 28, 1965:

- Natchez Mayor and Board of Aldermen are to condemn the White Knights Ku Klux Klan and Americans for the Preservation of the White Race!
- City of Natchez shall Hire Black Policemen!
- Natchez shall Provide Equal employment opportunities, hiring Blacks into white government and private sector jobs!
- City of Natchez shall Desegregate public facilities (parks, hospitals, playgrounds, city auditorium, etc.) as mandated by the July 2, 1964, U.S. Congress Civil Rights Act!

- City of Natchez shall desegregate public schools as required by *Brown v Board of Education* Supreme Court Decision of 1954!
- City of Natchez shall appoint an Afro-American to the public school board.
- City of Natchez shall adopt a federal funded Equal Opportunity poverty program with fund divided equally between Blacks and Whites!
- Police and government officials shall address Blacks as "Mr." and "Mrs." rather than "Uncle, Boy, Missies, Girl, Horse or Auntie!"
- Police shall provide escorts for Black funeral processions! [It was common then for funeral processions of white citizens who died to be given police escorts from the church or funeral home to the cemetery.]
- City shall enact an adequate housing code to help eliminate slums in the Black community!

In the modern age, such requests might seem reasonable, but in the Klan-dominated Jim Crow South, those requests, despite Evers's "most precious" comment, were pushing the envelope far beyond what white authorities were willing to concede. Thus, the requests were rejected, which was a devastating blow to the African American community right after the near-death of beloved George Metcalfe.

"We didn't get what we wanted," Evers told a gathering crowd in August 1965. "We didn't get anything. But we haven't lost the faith. The mayor said he'd be ready to meet with the group. But things ain't never gonna get cooled off until they get something done downtown."

Ironically, the mayor at the time was John Nosser, a white man who truly wanted to achieve peace, but he was the target of threats and bombings at his stores, underscoring the volatility of the time.

Former Mississippi governor William F. Winter understood the pain the African Americans in Mississippi and Natchez were feeling:

> As long as they had no recourse at the polling place, they could not effectively express their displeasure with the system of segregation. So when the Voting Rights Act was enacted in 1965, that meant that protection was no longer afforded white people in the South. And therefore, black people were going to be able to vote, and they were going to be able to express themselves in terms of what they expected from their political leaders.

The passage of the Voting Rights Act, Stanley Nelson said, infuriated leaders of the Klan, leading them to try to kill George Metcalfe, but instead the attempted murder energized the African American community in Natchez, including the young Parchman survivors. Back then, nonviolent marchers consisted of those in their teens and early twenties because if their parents marched, they would have been targeted for job dismissals, punishments and beatings. So the challenge to fight for change fell on those youth courageous enough to march on public streets even though most were too young to vote.

There were some "guardian angels" watching over the marchers, however. An African American organization called the Deacons for Defense was armed with pistols and long guns. The Deacons, not necessarily church leaders, were composed of African American men who pledged secrecy to each other "to the death." They stationed themselves along marching routes, ready to take on the Klan. At the time, Evers and the NAACP pledged, according to the principles of Martin Luther King, to wage nonviolent marches and resistance to white dominance. Violence versus nonviolence was a tremendous debate point within the African American community.

"The NAACP never overtly promoted armed resistance," writes Akinyele Omowale Umoja, author of *We Will Shoot Back: Armed Resistance in the Mississippi Freedom Movement.* Here is the message of preacher Ernest Cunningham, who expressed the United League of Mississippi's perspective on guns, religion and nonviolence, as reported in *We Will Shoot Back:*

> *Nonviolence is good…and they teach that nonviolence has its place… in religion and you shouldn't carry weapons. But I always quote that particular scripture where Peter has a sword….He had to have a weapon. That was equivalent to a pistol during his day….It's nothing wrong with Christians and religious people carrying guns. It's what you do with the weapon. You carry it as a protection, for defensive purposes. Not to go out there and assault nobody. They're for protection. That's basically why we carried them. We weren't out there reckless.*

In Natchez, the Deacons for Defense, armed and ready, locked and loaded, walked alongside the nonviolent marchers or watched from rooftops. The result: no shots were fired on either side during the many protests and demonstrations.

Even so, young Natchez men and women, churned up over the defeat of the petitions to the city and the attempted assassination of George Metcalfe,

needed to express their anger and frustration. So they participated in large-scale marches of hundreds of youth, many bearing placards demanding rights. Stanley Nelson said:

> *So it's always ironic to me that the Klan in their quest to instill fear within the black community always had the total opposite effect. So they spent much time trying to kill Metcalfe; a lot of thought went into this. And these were not men that were just doing this for something to do, go out and have a few beers. This was serious business to them; they truly felt they were in a fight for the southern way of life for white people, and they were out truly to preserve it. Metcalfe was to them the true enemy…to cram integration down everybody's throats. They were out to get him, but they never did.*

"I was sort of like a little rebel, so I wasn't afraid," said Patricia Dixon Carroll, one of the young marchers. "My mom said, 'You can go, and if you get in trouble,' she said, 'we'll get you out somehow.' And then I used to listen to the speeches of Mr. [George] Metcalfe, and Reverend [Shed] Baldwin [a local civil rights activist] and Mr. [Charles] Evers, and they would say, 'Just be peaceful, and if you are arrested, we'll get you out.' So I wasn't too afraid, no."

Dixon Carroll said, "It was excitement in the air. You know, it was like we are finally going to do something to change the conditions that we live in. We're going to be peaceable, and there was some people who [were] older,

Left: Patricia Dixon Carroll. *Right*: Frederick Bernard.

much older than me, that I would hear saying things like, 'Well, I've got my gun.' Although they [NAACP leaders] said, 'Don't bring any weapons.'"

However, the young marchers didn't escape verbal violence aimed at them. "The way we were treated and people in attendance [watching us]… the things they would yell and say to you. It was pretty bad, pretty bad," said Frederick Bernard.

But that didn't stop them. They marched on, and many paid dearly for that courage and determination.

Note: George Metcalfe lived for twenty-four years after the bombing, passing away on Friday, April 21, 1989, at his home. His funeral services were at St. Peter Rock Baptist Church on Tuesday, April 25, 1989, with the Reverend F.D. Nash officiating.

CHAPTER 8

THE ARREST

So, actually it was like a cattle roundup because it was so many of us. From what I can remember, they started getting them [the young men and women] *up in the seats. It was hundreds of people, I swear. Back then, it looked like hundreds.*
—*Ronald Coleman, Parchman Ordeal survivor*

A chill enveloped Natchez in October 1965. Winter, it seemed, was forcing its way early. However, inside the small red brick Beulah Missionary Baptist Church, the heat of passion was inescapable—the heat of civil rights fervor that had gripped the African American community in the summer and early fall. Beulah Baptist Church bulged with enthusiasm, a common experience for the church that had taken a leading role in staging impassioned civil rights services, rallies and spirituals. A few blocks away, the China Grove Baptist Church also teemed with civil rights energy.

On Saturday, October 2, 1965, several hundred young men and women gathered inside both churches in preparation for a march through the streets of Natchez in support of civil rights and voting rights. Most were in their teens and early twenties.

"There was excitement in the air. You know, it was like we are finally going to do something to change the conditions that we live in," said Patricia Dixon Carroll, who was seventeen at the time. She continued:

I remember when we were at the Beulah Baptist Church. I think that was one of the most significant memories I have. And it was like there was like electricity in the air. It was as though, when you come to like a boiling

point, you say, "We are going to do something today regardless." And that was I think the most significant thing I remember, and that was the day that we decided we were going to march. We had been told by state officials and the city officials we couldn't march. And we said, "We're going to march regardless," and I was excited. And they said, "Well, you could get arrested." Well, we just get arrested. We knew that something big was gonna happen in Natchez that day.

Wilford Perkins, who was fifteen, did not want to miss out on "that something big."

Now that's an event I won't ever forget, I can tell you. It was like it was yesterday. It was a Saturday morning. A friend of mine—his name is Ronnie Coleman—we got dressed and we rode our bicycles up there to Beulah Baptist Church…and when we got there, everything was great. You could hear the singing and everything. We got inside, and we were just singing and clapping our hands and everything, just listening to the orator speak, and when everything was over, they were gonna get ready to go march that particular day. So I said, "Okay. Well, how we gonna do this?" He [Coleman] said, "Well, we just gonna ride on our bicycles along with the group." I said, "Okay. We'll do it that way." We were looking at our little Mickey Mouse watches that we had on to see what time the action would be started.

Ronald Coleman.

Ronald Coleman added: "Well that particular day, if I can recall, my mother and I and sister Daisy were at home, and they'd been talking about this march. They were going to go to the church and everything, and if they had to march, they would. My dad was telling us, 'If you go, be careful. Don't do this.' At this time, I'm around sixteen…well, seventeen [years of age] because I was a senior in high school."

He recalled, "The church was packed; it was full and probably some on the outside."

Gospel singers made the walls almost shake with such civil rights anthems as "We Shall Overcome" and "Ain't Nobody Gonna Turn Me Around."

Standing, swaying, waving arms, those gathered barely warmed the hardwood seats. Such high-powered services were nothing new for Beulah Baptist Church, which is off B Street just outside downtown Natchez. The brick and wood church was built in 1901 and remains active today.

Another ally in the fight for desegregation was the Reverend R.O. Gerow, Roman Catholic bishop of Natchez-Jackson. On August 6, 1964, about a month after President Lyndon B. Johnson signed the Civil Rights Act, Gerow published a letter to be read at Mass at all Roman Catholic services. It reads:

My Dearly Beloved Brethren in Jesus Christ:
I write to you regarding a matter to which I have given much thought and prayer and in which I have made a decision.
Accordingly, it is to be the policy of the Catholic schools in the diocese to admit qualified Catholic children to the first grade without respect to race. This is effective September 1964. Implementation of this decision will be handled by each pastor in consultation with me.
I call upon the Catholic people of Mississippi to give witness to a true Christian spirit by their acceptance of and cooperation in the implementation of this policy.
I rely upon your devotion and ask for your prayers that whatever adjustments ensue, they may rebound to the greater honor and glory of God and strengthening of the bond of charity which unites us all in Christ.
Wishing you God's abundant blessing.
Sincerely yours in Christ,
Most Reverend R.O. Gerow
Bishop of Natchez-Jackson

In the April 13, 2018 edition of the *Mississippi Catholic*, it was reported that one year after Gerow issued that letter, he desegregated all grades in Mississippi's Catholic schools.

In Natchez, the Catholic Church had been deeply involved in desegregation through the leadership of Holy Family Catholic Church, the first African American church in Mississippi. Holy Family, like Beulah Baptist Church, was a frequent meeting site for African American leaders and supporters, including several white Catholics.

"Beulah Baptist has strived over the years to be a trailblazer in the Natchez community," according to a pamphlet of the church's history. "The history of the Natchez Civil Rights movement would not be complete if it did not

Beulah Baptist Church.

include Beulah as a beacon of light and hope during the fiery days of fear and unrest during the 1960s. In October 1965, meetings at Beulah Baptist Church launched marches and protests" with hundreds of participants.

Conversely, the Ku Klux Klan also held rallies and marches numbering in the hundreds. Tensions had risen so high that on September 30, 1965, the City of Natchez obtained an injunction against marches, particularly those endorsed by the NAACP. At that time, the Natchez mayor and all the Natchez aldermen were white.

In spite of the injunction—or in some instances because of it—young African Americans said the marches, particularly nonviolent marches, were their only way to express their dissatisfaction with decades of segregation and discrimination not just in Natchez or Mississippi but throughout the South.

Despite the passage of the Voting Rights Act in August 1965, African Americans in Natchez believed they were no closer to obtaining full civil and voting rights. On August 27, George Metcalfe was nearly killed, and soon afterward, the city rejected African American leaders' petitions for equal treatment by the Natchez government.

Helping to fuel pro–civil rights action was Charles Evers, brother of slain civil rights leader Medgar Evers. Charles Evers, who was the field agent for the NAACP in Mississippi, spent considerable time in Natchez because the city had become a hotbed of friction between the Klan and African Americans.

Thus, on October 2, 1965, Evers was at the pulpit at Beulah Baptist Church, exhorting the participants to be brave and march peacefully. Nonviolence was a hallmark of the NAACP, urged on by the message of Reverend Martin Luther King Jr.

Alice Lewis recalled:

> *I went there to the church, to the rally, and when we went there, they told us they had put an injunction on us to stop us from marching, and we weren't gonna let that happen. The leader* [Charles Evers] *told us that they* [the authorities] *were out there outside the church, that media was out there, and that if we march out of that church, we were gonna be arrested. He gave people a chance to say,* "Well no, I don't want to do it. I'm gonna back out." *For me, I was in it for the whole nine yards.*

Delores Hence said, "So, we went to the church, and Charles Evers was there; he was talking and speaking and saying, 'Now, we're going to march in Natchez.'"

Authorities, though, had other plans for the young men and women. Armed with a newly passed city ordinance later ruled unconstitutional, authorities had arranged to have buses and paddy wagons outside Beulah Baptist Church, as well as China Grove Baptist Church a few blocks away where other marchers had gathered.

Hence said:

> *And so we got outside, we saw the Chief of Police J. T. Robinson. He said, "You're not going to march today…because if you march, then you're going to jail." So we backed up and went back in the church and told Charles Evers that they were out there waiting on us. He said he knew that. And everybody was sitting still…didn't want to march.….We were afraid. He started crying. He said, "My brother [Medgar] died for this." And when he started crying, that church got on fire. We just lit up, got up and walked down the steps. We just walked back out.*

According to church history, "The police chief ordered the gatherers to disperse." Evers, who had stepped outside with the gathering, then said, "If we turn around now, we'll turn around for years to come. Now is the time to take a stand and be counted whatever the price may be."

"We didn't march," Hence said. "We walked on the bus. 'Cause there was no marching. And they took us to the city auditorium, and that's where we were locked up all that Saturday, in the city auditorium. And they kept bringing more and more and more people [marchers] in."

Delores Young McCullen said, "So, we left Beulah Church and…and all of a sudden police came from everywhere and deputy sheriffs and firemen. There was just white people all over the place. Of course, we knew; we expected it. But never in my mind I thought I would be arrested."

The streets around both churches—Beulah and China Grove—teemed with onlookers, relatives and bystanders. Vehicles from full bus liners to police vans were employed to gather the young men and women to prevent them from marching.

Evers said, "I think we were all in an uproar. We were mad and we were just raising hell, you know what I'm saying. And then that's when the police said they were gonna break us up. The police came out there pushing us around, and we refused to go. We refused to stop. We were trying to get downtown, but they wouldn't let us."

Evers was a rough-and-tumble kind of fella. He was raised in a strict household in Decatur, Mississippi, a rural community near Meridian. "They

[his mother and father] were tough on discipline; we were never allowed to do anything they weren't satisfied with."

Race, he said, wasn't an issue in his neighborhood. "We were family. If my mother had a headache, all the neighbors came to see her. If anyone in the neighborhood was in trouble, we helped each other. Race was never a great issue. In Decatur, there wasn't black or white. We were taught to respect each other."

The sting of segregation and discrimination hit when he entered the U.S. Army during World War II. "It was just terrible; we had the worst accommodations. We had the worst food. And you have to remember then that back in America it was segregated, so why should there be any difference here [in the U.S. Army]. We had the worst barracks, the worst food and the hardest work."

Charles served his time in the Philippines in a construction unit, while Medgar was stationed in Europe. Both Evers brothers returned in the mid-1940s to the Jim Crow South and rampant discrimination. "I never forget when I came home, you got off the damn boat you came to Camp Shelby [a U.S. Army base near Hattiesburg, Mississippi], and got on the segregated bus to be told to get to the back seat. It affected me. Why did I go and fight and be mistreated by the people I signed up to defend? Why? Why? Because of the color of my skin!"

When Medgar returned, he quickly joined the fight for civil and voting rights, connecting with national organizations and taking on leadership roles, such as Mississippi's NAACP field agent. Charles, however, pursued a rather shady life in Chicago. "I ran numbers up in Chicago," Charles said. "I ran the jukebox business. Medgar said to me, 'You take care of yourself.' I said, 'You take care of yourself, too. I can take care of the Mafia; you watch out for the klukkers [Ku Klux Klan].'"

Medgar Evers was murdered by Byron de la Beckwith, a member of the White Citizens' Council. As mentioned earlier, this group was formed in 1954 to resist the integration of schools and civil rights activism. As a veteran, Medgar Evers was buried with full military honors at Arlington National Cemetery. His murder and the resulting trials inspired civil rights protests. His life also inspired numerous works of art, music and film. All-white juries failed to reach verdicts in the first two trials of de la Beckwith in the 1960s. De la Beckwith eventually was convicted in 1994 in a new state trial based on new evidence.

After Medgar was assassinated in the driveway of his Jackson home in 1963, Charles returned to Mississippi to take up where his brother left off.

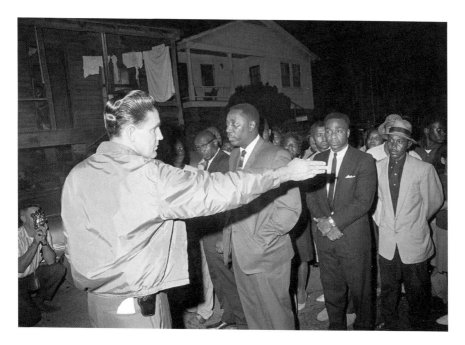

Natchez police chief J.T. Robinson extends an arm to halt a civil rights march led by NAACP field secretary Charles Evers (*with hand in pocket*) after it left a church in Natchez, Mississippi, October 4, 1965. Robinson told the marchers to either halt or be arrested and sent to the Mississippi State Penitentiary at Parchman to join several hundred demonstrators arrested in the past several days. The marchers returned to the church without incident, and there were no arrests on that night. *AP photo. Used with permission.*

Charles Evers did not shy from confrontation; he often stood face to face with white officials and even Klan leaders.

So it was in October 1965 when Charles Evers stepped out of Beulah Baptist Church with several hundred followers ready to march. Police, though, cited a recently passed city ordinance aimed at prohibiting marches without a permit and began to arrest the mostly young men and women, including some not yet in their teens.

Mary Nichols was one of those young women:

> *And we really weren't planning anything that night, just to leave church* [march downtown] *and go home. But when we got there* [outside the church], *they had a bus out there. It was…I never will forget it. It was a Trailways bus, and they said everybody was under arrest for parading without a permit. So as we were getting on the bus, I had my* [infant] *son, and I brought him on the bus with me.*

Perkins, who had traveled by bicycle to the church, said:

So once they opened the church doors, there were nothing but police officers and buses. So, okay. I looked at Ronnie [his friend Ronald Coleman]. *Ronnie looked at me. So we said, "Okay. Let's go get our bicycles and just try to go along." And we were going for our bicycles, and this police officer says, "Hey, you boys. Come on back here. Come on back over here." So we said, "Who, us?" He said, "Yeah, you two. Come on."*

So by that time, we left the bicycles there and we got on the bus. Once we got on that bus and they filled it up, they transported us to the City Auditorium.

The City Auditorium is a vast hall made for pageants, balls and performances. At that time, African Americans were not allowed inside. The hall became a detention center of sorts for the estimated at least seven hundred who had intended to march.

Coleman said:

So actually, it was like a cattle roundup because it was so many of us. From what I can remember, they started getting them [the young men and women] *up in the seats. It was hundreds of people, I swear. Back then, it looked like hundreds. And I'm still with my mom and my sister*

Natchez City Auditorium.

Daisy. They get us to sign in, I think it was, and ask us our name and age. Well, I was seventeen, and my sister was fifteen or sixteen years old. Anyway, they locked us in. It wasn't a jail. It was just a big auditorium. They start telling us to go sit down. They gave us a certain place to go sit at. The place constantly started getting full. So after a while, they start saying, "We gonna start taking these niggers somewhere else because this place is getting full." So things kind of like got quiet. My mom and I, we were just trying to give each other comfort as much as possible without showing fear.

By then, the street in front of the auditorium was packed with white and black onlookers as the young people were ushered out of the vehicles and into the hall.

Delores Young McCullen said:

It [the arrest] was scary. It was scary because there was a lot of yellin' goin' on, there was a lot of cryin' goin' on and there was a lot of, "What are you doin'?" And "Niggers, why are you here?" and "Niggers, you know better." I mean, and then they just herded us like cattle and bein' called dirty names at the time. And that's how we got transported to the City Auditorium.

Oh, when I walked in the auditorium, there was just people everywhere. Kids, adults, cryin', prayin', just sobbing and kids looking for their parents and parents looking for their children. It was probably at almost full capacity. So we were packed in there.

By that time, throngs of blacks and whites had gathered outside the auditorium, along with news media from around the state. One of the reporters was the award-winning Bill Minor, who passed away in May 2017. Minor was well known for his courageous journalism, particularly in reporting on civil rights incidents. He had reported on the assassination of Medgar Evers and the two trials of Evers's accused (and later convicted) murderer, Byron de la Beckwith. Minor was significantly moved by the brutal murder of Emmett Till and the trial of his accused white murderers, who were acquitted. Till was a fourteen-year-old African American from Chicago who in 1955 supposedly flirted with or whistled at a white woman in a store while he was visiting relatives in Money, Mississippi. In those days, black males were often accused of inappropriate behavior toward

white women who, like in the Till incident, made up the charges. The white woman's husband and his half brother went to Till's great-uncle's house several days later. They abducted Till and brought him to a barn in a rural area of the county, where they beat and mutilated him, shot him in the head and dumped his body in the Tallahatchie River. His body was recovered three days later. Later reports state other men were also involved. The brutality of his murder and the fact that his killers were acquitted drew attention to the long history of violent persecution of African Americans in the United States. Till posthumously became an icon of the civil rights movement.

Bill Minor recalled:

> But I'll just tell you when the [national] focal point of the inequity of justice for blacks and whites became evident in the Emmett Till trial. Two white guys being tried for murdering a black boy. I was sitting outside the jury room, and there's a flimsy wooden door there. I can hear the jurors...I mean, the outcome of the trial was never in doubt. An all-white, all-male jury gets the trial. They went in the jury room, spent an hour and five minutes, came out [with the verdict]: not guilty.
>
> [Before the verdict] I could hear them inside the jury room laughing and sending off for a Coca-Cola and things like that. The courtroom was just packed all the time. But the thing is, Till being from Chicago and his body was taken from the Tallahatchie River, his mother decides to put it on public display [in an open coffin] in Chicago, and some tens of thousands of people go past it, and they see how he'd been beaten before he was shot and killed.
>
> So the trial became a national story, and the point is it became the first national story that I ever covered that there were, as I recall, as many as seventy reporters from papers all over the country and even some from foreign countries, even from England. We had two guys from the British newspapers who came, and they couldn't understand the segregation system.

After the acquittal of the two white defendants, "Blacks began finally speaking up for their rights around the state," Minor said.

However, speaking up for rights also came with a price for African Americans, as seen in the assassination of Medgar Evers; the attempted murder of George Metcalfe; the beatings on the Edmund Pettus Bridge in Selma, Alabama; and the arrest of hundreds of African Americans in Natchez and being forced to the Natchez City Auditorium in October 1965.

Tommy Ferrell, former
Adams County sheriff.

"There were people that wanted to march en masse to demonstrate that they were serious about their civil rights," said Tommy Ferrell, former sheriff of Adams County, who was a college student at the time of the arrests. Ferrell's father Billy was sheriff from 1960 to 1964 and 1968 to 1988 and was succeeded by Tommy. Tommy said:

Well, the leadership in the city of Natchez and Adams County at the time didn't see fit to allow these kind of marches. They looked on these marches as a detriment to the community, not only because of the safety reason, but because they [marchers] demanded that they all be permitted [by city leaders] to march.

Well unfortunately, getting a permit (especially for an African American march) was very, very difficult, and that's what happened in the incident that happened in October '65. They had applied for a march permit; it was denied. They were warned by the city officials that if they marched anyway, that they would be arrested due to the civil disturbance. And that's why the large number gathered despite the warning, and that's why they marched anyway. And when they attempted to march from the church, the authorities moved in and arrested them.

Tommy's father, Billy, was not sheriff at the time of the arrest. However, he had links to the Sovereignty Commission, the Mississippi agency that kept close tabs on African Americans and those blacks and even some whites who helped them, according to a June 2003 report by Paul Hendrickson in his series "Sons of Mississippi" in the *New York Times.* Also, Billy Ferrell was one of many law enforcement authorities in attendance at the time James Meredith attempted to be the first African American to enroll at the all-white University of Mississippi in 1962.

Tommy Ferrell said he was dismayed by the arrest and detention of the young African Americans in the Natchez City Auditorium. Estimates are that seven hundred or more African Americans, most in their teens and early twenties, were locked in the auditorium in the initial wave of arrests. Over the next two days, more arrests occurred as African Americans continued attempts to march. Tommy said:

> *Well, as you can imagine, any mass arrest like that is total chaos, and the only venue, or the only area large enough to hold that many people, owned by the city, was the City Auditorium. So they were taken to the City Auditorium for decision-making, to decide what to do with these folk. They had been repeatedly warned, and because of the seriousness of the city administration's position, they* [city leaders] *felt like, at the time, they had to take some kind of action.*

Tommy Ferrell said he knew some of those locked inside the auditorium. "A lot of those people were my friends. I was born and raised here, and I knew a lot of them personally and grew up with them."

He added:

> *Remember, though, this is 1965. The community had not encountered problems of this sort. There's always been civil disturbance or civil disobedience, but not on this scale. So when a mass arrest of that size occurs in a town this size, that naturally draws the attention of a lot of people. So there were a lot of spectators, a lot of bystanders and things like that, that went to the City Auditorium to see what the spectacular event was. And that's when we encountered this large mass of people, men, women and children. Kind of sad.*

What occurred next shocked Ferrell and Minor and sent fear into the hearts of those in the auditorium.

CHAPTER 9

DARK RIDE INTO TERROR

During the night, without my knowledge or any knowledge of any journalist, this sheriff sends buses out to the City Auditorium and loads them up with people who were inside the auditorium. Bam, takes them straight to Parchman Penitentiary. I mean, this is where only the most violent criminals in the state were brought, and that's where they had death row. I mean, they had the gas chamber.
—*Bill Minor, journalist*

The Natchez City Auditorium can accommodate close to one thousand people seated. The brick and concrete structure features six massive fluted white columns, tiered seating, hardwood flooring, a step-up stage with tall drawn curtains and side wings for pre-event staging. Constructed in 1938–39, the building was a product of the Federal Emergency Administration of Public Works, according to the Mississippi Department of Archives and History. Two city blocks are needed to accommodate the auditorium, its grounds and splendid trees.

Between the auditorium's completion and 1965—a period of twenty-six years—African Americans were not allowed as spectators for the many events held there—concerts, pageants, dances, etc.—even though the building was a federally funded facility.

And then in early October 1965, the auditorium was nearly packed with African Americans of all ages, not by their choice but by force, bused from their Baptist churches where they had prayed for peace and rights, where they had heard civil rights activist Charles Evers come to tears about the

need to march, where they had planned a nonviolent march to demonstrate for civil rights in an era when there were almost none.

This was a pivotal moment for Natchez authorities. Media had descended on the city streets around the auditorium along with throngs of whites and blacks, including Charles Evers. He said:

> *And when they put them all under arrest and started loading them up, I said, "I'm not going." I said, "Somebody has got to stay out." Then lo and behold, they left me out to get those who were going to Parchman out again. And that was it. So they loaded them up, carried them to Parchman and had them just like a bunch of hogs in a pen. No respect at all.*

Evers admitted he knew the arrests might occur but said that he never realized dozens would be taken to Parchman Prison. Police Chief J.T. Robinson charged the hundreds locked inside the auditorium with parading without a permit, a city law created to prevent African Americans from marching. Back then, it would have been unlikely, if not outright impossible, for blacks to be granted such a permit. Their "infraction" was a misdemeanor, which should have resulted in their release. Dozens were released—mostly the pre-teens and elderly—while dozens more were sent to local jails. When the jails filled up, more than 150 remained in the auditorium awaiting their fate.

Former sheriff Tommy Ferrell concurred and said:

> *They should have been released immediately, similar to what goes on today—you take them through the process, if you're gonna charge or not charge, either release them or incarcerate or be forced to make a bond to appear, whether it be a recognizance bond, where they could be released on their own name, that should have been done right here. Or there should have been nothing done. If there was an attempt not to charge—and quite frankly, I think during that period of time the city administration didn't know what to charge because they were exercising their civil rights, which had just been granted by a federal court system and the Congress of the United States. So they didn't know if what they were gonna charge them with was legal or not.*

Inside the auditorium, tensions were mounting as the young men and women waited hours and hours to learn of their fate.

"It just was people everywhere. I mean young, older people, some children, you know. And people was, I guess, getting word to other people to come and

see about us and come and get the children," said Mary Ann Nichols, a Parchman Ordeal survivor.

Delores Hence said, "The auditorium was very noisy, a lot of people all around sitting, and people were singing and praying and singing freedom songs. So everybody was saying, 'We don't know what going to happen to us' because people keep coming and coming. And we just didn't know what was going to happen."

Georgia Mae Sims added, "I had never been in there before in my life. I was eighteen years old. We weren't allowed in there. As far as I know, no blacks had ever had any type of occasion to be in the City Auditorium. It was all white only."

Delores Young McCullen said:

> I mean, you got cops with clubs and, you know. So we just did what we were told. I was fifteen at the time, so in my fifteen-year-old mind, it was like, okay, we're gonna go home soon. Nobody told us we were going to Parchman. But I did recollect that after we reached the auditorium, after some time, we were there for hours and hours, and somebody had the notion that we might be hungry. So they brought in cheese sandwiches for us. All day…[only] cheese sandwiches. The food was provided not by local authorities but churches and the NAACP.

Earl Turner recalled the time he heard of the fate of those remaining in the auditorium:

> The chief of police at that time was J. T. Robinson, and he was telling Mr. Evers and several others that they didn't have a facility to house us in jail, that they were gonna take us to Long Brothers Stock Yard. But the weather was so bad, it was kinda cool during that time in October so they said the facility wouldn't accommodate us.
>
> So then they came along and said, "Well, we'll send them to Parchman," and we was yelling, "We're going to Parchman!" We wanted to go, 'cause we didn't know the circumstances. We thought it was fun. We said, "They gonna give us clothes and feed us good and say they gonna house us 'cause they didn't have enough jail facilities here."

Turner and the others soon learned those circumstances weren't "fun."

Ronald Coleman said:

Well, I don't think at that time I had ever been on a bus, a Greyhound bus anyway. Before we left [the auditorium], they were separating. They were calling off in I think alphabetical order or something of that nature. But they took my sister away, and they were saying someone had to come pick her up because she was underage. We were talking and we were singing. They said, "How you going to take us somewhere and we haven't had a trial? We haven't been found guilty or anything." So they held my sister until someone came and picked her up. My mother and I were loaded on the bus, and we tried to stay together. Actually, we did stay together. I made sure she stayed with me and I with her.

All the way up there, we had been intimidated, scared not to sing, not to do this or we goin' to get our ass whupped. So my mom tried to keep me in a peaceful mode, as I did her. So we kind of like held hands and said, "It's going to be okay. It's going to be all right. We not goin' to be here long. We goin' to be getting out in the morning."

While the young men and women awaited their fate inside the City Auditorium, authorities outside once again ordered buses.

McCullen said:

And then [in the auditorium] we were kind of separated and we were sent to different sections where they [law enforcement authorities] had these little tables set up and people were taking your name and address and telephone numbers, I guess so if parents were lookin' for you, they can find you. And we did that, and we had a seat. And I don't know how they picked us to go where. But next thing I know, we were told to get on this Greyhound bus. And we were going to Parchman. And I'm going Parchman; what is Parchman? I knew nothing about Parchman.

Alice Lewis said:

I really didn't think they were serious about sending teenagers to Parchman, and next thing I know, I'm on a bus riding to Parchman, and my fear was that they can go put us in a mass grave and nothing would be done about it. I had no idea Parchman was that long away. I think they say like two or three hours from Natchez, and the whole while we were riding up there, it was at night, pitch dark and I was afraid....My thing was, I'll never see my siblings again, my parents again, because I figured the worse is gonna happen to us.

Tommy Ferrell said, "I remember watching them [police] load up on those buses and the entire crowd standing around saying, 'Where are they taking them, and why?' And that's when we were told they were going to Parchman."

Wilford Perkins said:

Once we got on that bus [at the church] *and they filled it up, they transported us to the City Auditorium, and I was nineteen years old, Ronnie* [Coleman] *was eighteen. So the guy, the police officer, made an announcement. The auditorium was full. I mean it was packed. Packed full. Police officers everywhere, and we're in the seats. So he* [the officer] *made an announcement that anybody who was eighteen years or older, "Come down here and get on this bus." I said, "My goodness. Where are we going now?"*

Fear gripped Delores Hence:

So later that night, maybe 11:00 p.m. or 12:00 a.m., they say buses are out there, the bus is going to take us somewhere. We didn't know where. Then we got on the bus. And when we were getting on the bus, I looked over and I saw my mother. She was calling for me, and I waved at her, but they say, "Keep moving, keep moving," you know, just making us get on the bus.

Well, most of the people were calling for their loved ones and waving and everything. They were saying, "It's going to be all right, we gonna get you out of there, it's going to be okay." Mostly they were saying that, but nobody really knew where we were going. We didn't know where we were going. They say, "Get on the bus," and the police with their little sticks and pushing you and shoving you, "Come on, come on, let's go." And we hurried to the bus and got on it.

So we got on the bus, somebody said we're going to Parchman. Parchman? That's the prison! What are we going to prison for? They said they didn't have enough room to house us because more and more people keep coming in [after being arrested at the churches] *that they had to send us to Parchman. So one man on the bus was saying, "Ooh baby, let's pray, because we don't know where they going to send us. They might kill us. They might gas us." So we were just singing and crying and praying…*

And there it began, one of the greatest injustices of the civil rights era.

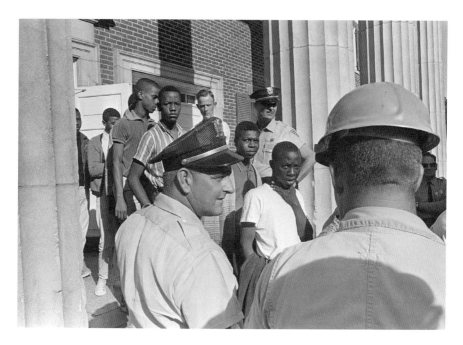

Police watch as young African Americans are taken from the Natchez City Auditorium in October 1965. *AP photo. Used with permission.*

Earl Turner, though, thought he was going to earn a badge of civil rights honor:

> *I was on the second bus, and they had three buses that were headed to Parchman. So when we left Adams County, they escorted us, the police, sheriff and the highway patrolmen. So when we got on the outskirts of Adams County, then the escort was just the highway patrolmen. So then they had the guards on the buses, and we were singing and…celebrating that we were going to Parchman. And they were laughing at us like it was a joke.*

Turner, as we later learn, realized how serious and deadly this trip had become.

Delores Young McCullen said:

> *The bus ride was, it was terrifying. It was really terrifying because it was black dark at that time of the year. And it was a long, long ride. And you know, I don't even know if anybody on the bus knew where Parchman was at the time. You know, we had never heard of it.*

By then, I'm so terrified now, I'm looking for my brother. My brother was who kept me confident at that time [of marches]. *As long as I was with my brother, I was feeling okay. I felt safe. But once we got on the bus, I got separated from him. And I couldn't see him. And along with the fear and the unknown and* [wondering] *where's my brother, it was just like, all of a sudden I'm cryin' because now I'm really scared.*

But I'll never forget, there was a young guy sittin' next to me, and his name was Luther, and he looked at me and he said, he said, "Don't cry. We're gonna be all right." And he took my hand. And he held my hand from Natchez to Parchman. And that gave me a little confidence. But still, everybody was just so afraid.

So we just rolled and rolled, and it was just fearful because we had seen movies where people were being taken off and hanged and killed and left [for dead]. *And we didn't know if they were just taking a busload of us to kill us. I mean, it was just…it was just a fear of the unknown. It was just so terrifying. Everywhere you look it was just dark, dark, dark.*

Ronald Coleman said, "Well, leaving out, like I said it was dark. It was nighttime. We were being told to shut up, don't sing. They [authorities on the bus] were threatening us the whole trip up there. I hadn't really seen that much of a highway at nighttime."

Keep in mind, these "passengers" were young—fourteen for some—filling buses heading north some four hours into territory many had never been, traveling on U.S. 61 North, then a relatively rural highway by small towns such as Fayette, Port Gibson, Yazoo City, Indianola and Sunflower, before reaching the town of Parchman. Few African Americans in Natchez at the time would have risked such a drive for fear of being pulled over by authorities and accused of some infraction or another, maybe jailed, maybe beaten, maybe killed or being stopped by the Klan. Coleman remembered:

Being seventeen, we [the family] *didn't do a lot of traveling. But I can remember real good seeing the sign say, "Welcome to Sunflower County." And I wondered,* Sunflower County. *Then after a while, we saw a sign saying, "Parchman." So now we know that we are being arrested and* [arriving] *at Parchman.*

Parchman is the oldest prison in Mississippi, founded in 1905, built with inmate labor and operated as a penal farm for decades. Originally, Parchman Prison housed black inmates but was integrated in 1917 with

segregated work camps housing male and female prisoners farming the vast land around the prison. In its early years, the prison housed approximately two thousand inmates. Today, it has beds for close to five thousand inmates in minimum-, medium- and maximum-security sections, including a death row and execution chamber. The prison is located on approximately twenty-eight square miles.

Located about one hundred miles south of Memphis in the Mississippi River Delta, the birthplace of the blues, Mississippi State Prison in Parchman, Mississippi, has become as much a historical landmark as it is a penitentiary. It's about thirty miles from where Emmett Till was murdered in 1955 and is surrounded by uninhabitable swampland.

"Parchman is often called one of the worst prisons in America. In the past century, the penitentiary has been the site of numerous injustices: It used slave labor long after emancipation; it perpetuated segregation long after the Civil Rights Act; and violence has long been commonplace. Federal court rulings and a series of reforms have improved conditions in recent years," according to the report "Letter from Parchman: Inside Mississippi's Notorious Prison" by Parker Yesko in the publication *Illuminating Journalism* from American Public Media.

Yesko further writes:

The origins of Parchman Farm reach back to the fall of the Confederacy. In 1865, the 13th Amendment abolished slavery, and from one day to the next, the population of free blacks in Mississippi nearly doubled. To whites, especially those with money and power, this posed an existential threat. There was one exception in the Thirteenth Amendment that gave plantation owners an opening: The protection against enslavement didn't extend to convicted criminals....

It took the Mississippi Legislature less than a year to pass a series of laws designed to subjugate African-Americans anew. Known collectively as the Black Codes of 1865, the laws used an expansive definition of vagrancy to criminalize all types of people: beggars, jugglers, drunkards, night-walkers and "all other idle and disorderly persons" who neglected their work or misspent their money. The Black Codes made it easy to run afoul of the law, and law enforcement used them to systematically arrest African-Americans. Before long, the population of black lawbreakers in Mississippi surged.

But there was no prison system to accommodate it. The state penitentiary in Jackson had been torched by Union troops in 1863, and it had only

really housed white prisoners anyway—black slaves had been disciplined on the plantation by their masters.

In post-emancipation, pre-Parchman Mississippi, the state needed a way to contain its new convicts. So it started leasing them out as laborers to plantation owners, railroad builders, lumber titans and the like. In exchange, these private companies paid a small fee to the state and covered the convicts' cost of living.

The convicts were kept in horrible conditions. Their leaseholders could treat them even worse than slaves because they cost less to replace. They underfed them, left them to sleep outside while chained together and forced them to work endlessly long days. If a convict escaped or died—and they did—another one was sent in. This cheap and inexhaustible labor supply became a major profit-driver for big businesses. Soon, the state of Mississippi decided to get in on the action.

Author David Oshinsky, in his award-winning book *Worse Than Slavery*, writes, "There were two reasons for Parchman. One was money-making and the other was racial control. They went hand in hand."

Parchman as a prison and farm system was born officially in December 1900 when the Mississippi Penitentiary Board of Control purchased thirteen thousand acres of fertile land in Sunflower County. In 1903, James Kimble Vardaman was elected governor. "Vardaman was a populist and virulent racist, and Parchman fit neatly into his platform. He opposed convict leasing because it benefited big business operators, not the poor rural whites who had voted for him," wrote Yesko.

So, under Vardaman's policies, the prison became a moneymaker not for the agricultural capitalists but for the State of Mississippi. According to Yesko, "By the end of its second full year of operation, the new penitentiary had earned $185,000 for the state (roughly $5 million in today's dollars), generated mainly by the many farm camps scattered across the Parchman plantation."

Yesko continues:

The workdays could run 15 hours long and 100 degrees hot. Though the inmates suffered from exhaustion, heat stroke, illness and injury, the prison kept running. According to Oshinsky, a traveling sergeant named Long-Chain Charlie regularly collected new farmhands from county jails around the state. A leather whip known as Black Annie was used liberally on inmates. Corporal punishment was administered by and according to

the whims of the "trusties," armed inmates drawn from the ranks of Parchman's most violent offenders who were empowered by prison officials to brutally maintain order.

In the decades that followed, inmates grew peas, oats, corn and potatoes. They raised hogs and cattle. They planted cotton, picked cotton and ginned cotton. The women's camp stitched the cotton into clothes, including those worn by inmates.

Parchman Prison, it seems, remained frozen in time.

However, by the 1960s, Parchman Prison began to become exposed to the outside world, chiefly because of the imprisonment of the Freedom Riders during the Freedom Summer of 1961, when the Riders arrived by the dozens in Jackson, Mississippi. The national media's lens and pens focused on the prison and revealed the deplorable living conditions.

According to Yesko's report, "With the passage of a state prison reform bill in 1964, small changes began to take hold at Parchman. Use of the lash, Black Annie, was banned. Mechanical equipment was brought in to increase agricultural yields and ease the physical toll of farm work. Vocational training and job counseling were offered for the first time."

However, "At the end of the 1960s, nearly 80 percent of Parchman guards were still armed inmates who often brutalized those they'd been charged to watch," Yesko wrote. According to Yesko's report:

In 1971, four Parchman inmates—Nazareth Gates, Willie Lee Holms, Hal Zachary and Mathew Winters—sued the prison superintendent, the six members of the state penitentiary board and Mississippi Governor John Williams in federal court. Their complaint claimed that the living quarters at Parchman were infested with maggots and rats, that raw sewage was dumped in the open, and that inmates were overworked, underfed, denied medical care and subjected to routine violence. Federal Judge William Keady agreed. In his 1972 judgment, Keady found that "the living conditions provided for the inmates…are generally deplorable and subhuman."

Yet Yesko said that Parchman superintendent C.E. Breazeale told the *New York Times* in 1968, "We're trying to get away from the idea that while a man's here we've got to get out of him every pound of cotton there is in him."

Breazeale had been the superintendent three years earlier when dozens of young men and women arrived from Natchez. As we will learn, Parchman still had not shed its brutal behavior.

Prior to learning about the Parchman Ordeal, it is important to realize that state and prison officials had experience imprisoning civil rights advocates.

May 24, 1961, was a warm, sunny day in Jackson, Mississippi. Two Greyhound buses en route from Montgomery, Alabama, to New Orleans had scheduled a stopover in Jackson. It should have been a quick and casual stop—water, refreshments and leg stretches. Except these buses carried the Freedom Riders, young white and black men and women from the North and South who sought to raise the attention of the country to the injustices of segregation and oppression and to support civil rights and voting rights. They were educated, determined and unafraid. Remember, this happened three years before passage of the Civil Rights Act and the Voting Rights Act.

By then, the riders had been exposed to all kinds of animosity by whites. During their journeys through the South, the Freedom Riders were met with a variety of challenges and attacks. Reports from National Public Radio and National Public Broadcasting tell just one story of the Freedom Riders' plight:

On May 14, Mother's Day [1961], *in Anniston, Alabama, a mob of Klansmen, some still in church attire, attacked the first of the two buses* [the Greyhound]. *The driver tried to leave the station, but was blocked until KKK members slashed its tires. The mob forced the crippled bus to stop several miles outside of town and then firebombed it. As the bus burned, the mob held the doors shut, intending to burn the riders to death. Sources disagree, but either an exploding fuel tank or an undercover state investigator brandishing a revolver caused the mob to retreat, and the riders escaped the bus. The mob beat the riders after they got out. Only warning shots fired into the air by highway patrolmen prevented the riders from being lynched.*

When the bus arrived in Birmingham, it was attacked by a mob of KKK members aided and abetted by police under the orders of Commissioner Bull Connor. As the riders exited the bus, they were beaten by the mob with baseball bats, iron pipes and bicycle chains.

Steadfast, the Freedom Riders continued their journey, arriving at the bus terminal in Jackson.

"As soon as they got off the bus, they were immediately arrested," as written by the Mississippi Civil Rights Project's web repository.

After they were sentenced to jail, more and more Freedom Rides took place, often ending in Jackson where they were arrested. More than

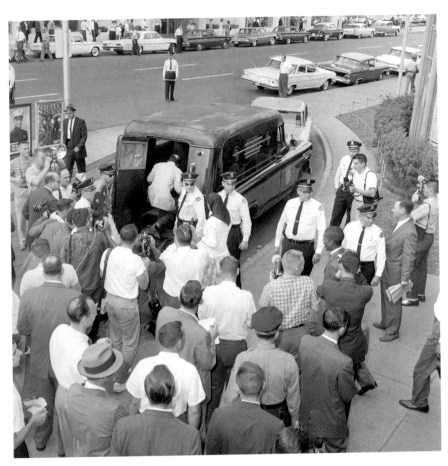

Arrested for a "breach of the peace," newly arrived Freedom Riders are loaded into the paddy wagon at the bus station in Jackson, Mississippi, June 29, 1961. Unlike Alabama during the first Freedom Rides, Mississippi adopted a policy of preventing attacks on the riders but arresting them without using segregationist laws. *AP photo. Used with permission.*

Some face Parchman—
Arrested riders now stand at 110

JACKSON, Miss., June 14—(AP)— The number of "freedom riders" stood at 110 today while plans were laid to move those still in jail here to the state penitentiary.

Since May 24—three weeks ago —today—110 have been convicted here of breach of peace charges, 24 have been released on bond, four have paid fines, and 24 are free on bond.

HE SAID HE told no one he was from Mississippi and the Congress of Racial Equality (CORE) gave him $20 to get from Chicago to Nashville, Tenn., and $15 to get from Nashville to Jackson.

"They are making fools of some Negroes," he said.

He said one of the white women freedom riders told him on the bus trip she had been to Cuba and

News story about the Freedom Riders' arrest in 1961.

Ross Barnett, Mississippi governor at the time of the Freedom Riders' arrest.

300 Freedom Riders were arrested, and many of them were sent to the penitentiary in Parchman.

[At Parchman] *Freedom Riders were kept in poor conditions— given clothes that did not fit, not allowed to exercise or leave their cells, and often served inedible food—and ridiculed by prison officials. When the prisoners refused to stop singing freedom songs, their mattresses were taken away. However, the jail also served another purpose. According to Raymond Arsenault in* Freedom Riders, *"In effect, the Freedom Riders turned a prison into an unruly but ultimately enlightening laboratory where competing theories of nonviolent struggle could be discussed and tested. In the darkest corners of Parchman, where prison authorities had hoped to break the Riders' spirit, a remarkable mix of personal and political education became the basis of individual and collective survival."*

At the time, Governor Ross Barnett, who had sent word not to hurt the Freedom Riders, told prison authorities to "break their spirit, not their bones."

Former governor William F. Winter said:

> *The way we treated those Freedom Riders in 1961, I think, remains a blemish on the good name of the state of Mississippi. And I have publicly apologized to people for having let that happen. We should not have let that happen. We should have had more respect for the Constitution of the United States and not been a party to keeping people from voting. That's what it was all about. Those Freedom Riders who came in here to try to get people to be able to vote were locked up, sent to Parchman for no crime at all. But for what they were doing, and that was to seek to get people eligible to vote.*

William Faulkner referred to the prison as "destination doom" in his novel *The Mansion.* For the young men and women from Natchez in the fall of 1965, Parchman would live up to its nickname.

Note: The Mississippi Department of Corrections declined our requests to visit Parchman Prison and photograph there.

CHAPTER 10

THE PARCHMAN ORDEAL

When the bus stopped, I remember we had guards. I know it was like two police officers, and I want to say one was a fireman, you know, in the front of the bus, just like you see on TV now. And when the bus stopped, one of 'em said—he had his back turned, I don't know which one it was—but I remember him saying, "We're here now, get your black asses off." And they herded us off. They pushed us and shoved us.
—Delores Young McCullen, Parchman Ordeal survivor

Note: You will hear from a variety of survivors. Some have similar stories, but each is presented to give the survivors their voice in this incredible and terrible experience.

Long stretches of farmland extend deep into Sunflower County some four hours north of Natchez. The town of Parchman itself is between the two small towns of Drew and Tutwiler. For all practical purposes, the prison *is* the town of Parchman. Streets near and around the state penitentiary are even named Parchman roads. Houses are chiefly for the employees of the prison. There are no malls or entertainment centers. The prison is isolated and meant to be that way. Its massive concrete blocks rise from the flatland, giant gray soldiers in the war on crime: murders, rapes, armed robberies, kidnappings and the like.

However, in early October 1965, buses bore dozens of young men and women from Natchez, nearly four hours away, who had committed no crime at all but had merely attempted to walk peacefully through the

streets of Natchez to advocate for their rights, particularly voting rights that had been granted in August 1965 by the U.S. Congress and signed into law by the president.

These were not grizzled, hardened criminals but fresh-faced young men and women, mostly in their teens and early twenties, many of whom had never been arrested but now were charged by Natchez authorities for parading without a permit, though they didn't parade and they were denied a permit to do so—by white authorities whose permit ordinance was later ruled unconstitutional.

As noted by veteran journalist Bill Minor, who reported the arrest, Parchman Prison was where only the most dangerous criminals in the state were sent. As we have seen from the incident with the Freedom Riders, the State of Mississippi didn't flinch in using the prison as a "teach-them-a-lesson" tool to punish civil rights advocates.

Minor said:

> *Well, that's it. You get to the heart of Mississippi's problem is that they are using authority, which is actual illegal authority, and using that to punish people. That's the question that gets to the heart of the way whites were treating black people back then. I mean, you're asking why did they do it? That's the whole question. Why did they have to be punished for just holding a sign and saying we want our rights?*

And *punish* is the correct word to describe what happened during the Parchman Ordeal, as we will read in the words of those who lived through the ordeal.

There were three waves of transports from Natchez to Parchman Prison. The first on October 2. A convoy of three or four buses driven by white operators and accompanied by a mix of local and state vehicles arrived at approximately 4:00 a.m. Another wave occurred on October 3, again with several buses accompanied by authorities, and the last on October 4 with one bus. Survivors said police and even firefighters stood watch on the buses. In all, about 150 young men and women, most in their teens and early twenties, were imprisoned for days, during which time they underwent abuse, punishment and humiliation.

Manuel McCrainey described arriving at Parchman Prison:

> *I had no idea where I was going. It was frightening. If I sit here and tell you that it was not frightening, I would be telling you the untruth. When*

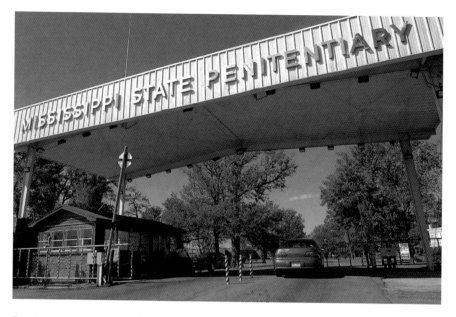

Parchman gate. *Courtesy the* Clarion Ledger, *Jackson, Mississippi.*

we did arrive at our destination, it was Parchman Penitentiary. I truly got frightened. All I can remember is there was a state policeman who said, "The last—and he used the N—to get off this bus I'm going to kick his ass." I'm no hero. I knew I was not going to be the last one. The last person that got off that bus was on crutches. They kicked his, like they said. At that point, I truly was afraid.

High chain-link fences, barbed wire, menacing guards barking orders and gripping the leashes of guard dogs, blaring lights and guns greeted the young men and women.

L.J. Bell remembers, "They had the dogs out there. He [a guard] said, 'I'll turn these dogs on the lot of you.' There was a man in the tower with a sub-machine gun. He threatened us, said he hoped we'd run or break for it so he could shoot us down."

Delores Young McCullen remembered:

When we got off the bus, we were bein' pushed and shoved and called niggers and all kind of bad names and this and that. But it was really frightful because when they took and they lined us up, they separated the guys from the women. And so they lined us up single file line; they had

our backs toward a fence, which we were told it was an electrical fence, so do not touch it. Then in the front of us, they had their dogs. They were standing there with the dogs on a leash.

So we had dogs barking and growling, slobberin' at the mouth at us, and an electrical fence, and we're in between the two of 'em. Then they thought it was funny to, you know, push the dogs towards you and get that close and snatch 'em back. They just played with our fear. It was really just horrible.

Ronald Coleman said:

We had some white guys with us also, that was marching with us. I can remember some guards going to get some shears, say, "We gonna shave you [to a young white man]." And we were wondering what they meant because we knew there was no electricity out there, but these here were some manual shears, and he just started dry shaving this guy. It was painful for him. We had another guy. They pulled his beard, was going to pull the hair off of it. So now, fear factor is really sitting in because we don't know…I didn't know what they were going to do with us.

Arrest records, which delineated between "C" meaning colored and "W" meaning white, indicate about six to ten of those sent to Parchman from Natchez were white. African Americans interviewed often said the white supporters wanted to go with them.

One such white supporter was Alec Shimkin, a history major at the University of Michigan. According to his friend Michael Walter, "The murders of Goodman, Chaney and Schwerner in Mississippi in 1964 made an impact on him."

Shimkin traveled to Alabama and participated in the Edmund Pettus Bridge marches in Selma and was arrested. He then learned of the struggle in Natchez, according to Walter, and made his way to the city to help with civil and voting rights.

Shimkin's sister Eleanor "Ellie" Shimkin-Sorock said:

Alec Shimkin. *Courtesy of the Shimkin family.*

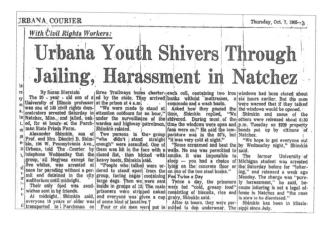

News story in the *Urbana [IL] Courier* telling of the arrest and incarceration of Alec Shimkin.

I think Alec found camaraderie and purpose in this work that he had been looking for in college; he was no longer isolated, and he gradually found some genuine friends. As a result of this new situation, he was grateful, enthusiastic and committed. The people he marched with, demonstrated, worked with, might not have been close friends, but he cared about them. With this sense of solidarity, along with his lifelong sense of determination, I don't think it would have occurred to Alec not to have joined his fellow demonstrators at Parchman.

In Shimkin's hometown newspaper, the *Urbana [IL] Courier*, Shimkin was quoted as saying of the experience: "Some [of those arrested] screamed and beat the walls. It was impossible to sleep—you had a choice of lying on the concrete floor or on one of the two steel bunks."

The story "Urbana Youth Shivers Through Jailing, Harassment in Natchez" further stated: "We were made to stand at attention outdoors for an hour [after arriving at the prison at approximately 4:00 a.m.], under the surveillance of the warden and highway patrolmen. Two persons in the group who didn't stand straight enough were assaulted. One of them was hit in the face with a closed fist, then kicked with heavy boots." Sadly, Shimkin died several years later, reporting from Vietnam as a correspondent.

Parchman authorities, it seemed, had developed a plan for treating the folks from Natchez even before their arrival. "To send us to Parchman, it had to come from higher up, and that meant the governor and the mayor and then the chief and the sheriff," said Georgia Mae Sims.

Delores Hence said:

Okay. We got off, and they were leading us to a room. And the women went in one room and the men went someplace else. It wasn't in the same building. We didn't see the men anymore, but anyway, being a woman, I went in a room with all of the other women. And there was a man, I remember a man giving us a laxative and a silver cup. And there was a woman, she checked our hair. She was checking for pins and everything and told us to pull off our top garments, and that's what we did. And then this man told us to drink this laxative. And I couldn't hardly drink it. And he said, "Girl, drink this laxative, because you had no business being in Natchez this time of morning, here waking us up [at the prison]. Drink it. Drink it." So I did the best I could and I drank it, swallowed as much as I could.

Terrible. Terrible. I didn't know; they said it was Parchman. I've never been to prison before. I'd never done anything wrong. I was scared. I wanted my mother. Oh, it was just terrible, and all the other people, separating people from each other. I didn't know what was going on.

They gave us some toilet tissue, a little; it wasn't very much. "Take this with you." So we got into the cell; there was four of us in the cell at the time. There were no covers [on the cot]. It was like tin on top. A top bunk and a bottom bunk. And it's cold tin and a commode right there, and we had to pull off our shoes and it was cold, the floor was like concrete. So every five minutes, everybody was vomiting. And then diarrhea came. Then the next day, they brought in two or three more people, and we were all huddling up on each other, trying to keep warm because we were very cold. It was so cold in that prison. Ooh, it was cold.

Hence shivered her shoulders to accentuate the feeling she had back in 1965.

Like I say, to me, I had never been separated from my mother that long. I had never in my life had been to jail. It was horrifying for me. I cried, I cried, I prayed and I cried. Then I woke up and I looked [out the window]. I saw a bird on the wire, and I said [to myself], "Oh Lord, that little bird is free and I'm in jail. I'm in jail." And I hadn't done anything [wrong].

Earl Turner described his experience:

So when we got to Parchman, the buses went through the gate. They kept everybody on the buses [unloading them one bus at a time]. So when we got in [the prison], they told us to take your clothes off to your

underwear, and then you walk a little further in line, and then they give you a laxative, coated chocolate in a cup. Everybody drank out the same cup 'cause you could tell by the rim of the glass that it had been used, so you couldn't deny it, 'cause they were forced to drink it regardless. You couldn't even ask what it was. So we went on in and…you go to another section up the line and they give you a physical, like make you bend over and check you back there, give you an examination.

So when they got to me, I was in my underwear. And one of the guards ask me, "Are you a goat?" I said, "No." He said, "Well, why you wear a goatee?" I wore the same type goatee in 1965 as I wear now. He said, "Well, you don't need it," and he snatched it. And he pulled it out. Boy, you talk about hurting. And it irritated my skin, but I had to accept it.

So after doing that, I went another step and then that one even made me get completely nude. Told me to wrap my stuff up in my shirt, and he gave me a piece of paper and said, "Write your name on it," and then all the clothes out of the first busload were lying over there, and I just was so nervous and frightened 'til I just bundled it up and I don't know where the tag went. So I put it over there, and then he said, "Go over there and wait." And after the people behind me were processed, then we were escorted to a cell and my cellblock…my cell was cellblock 5.…It was in the death ward.

Recalling from chapter 9 the passage about the Freedom Riders, they, too, were housed in the cellblocks where the death chamber was located. Some of the Parchman Ordeal survivors, like Earl Turner, remember their cell number, which correlates to narratives of the Freedom Riders' cell numbers.

Ronald Coleman said:

But it really got scary when they unload us off the bus and they start separating the male and female. So at this time, I'm really getting worried because now they taking my mom from me. I felt almost like a baby. I'm fixin' to lose my mom. I don't know where she's going, and she didn't know where I was going. So the story just kind of start twisting now because the fear factor really sits in for me wondering, "I'm going to be okay, hopefully, but my mom…I don't know." Black female woman, good-looking lady [his mom], long pretty hair. I'm like, "Hey, who knows what's going to happen up here."

But they lined us up, and they made us stand in the line. They had some dogs out there, and they had this light, the prison light. You can see

the barbed wire and everything, and they were telling us to be quiet, shut up. There was some singing. The prison guards start coming along with the dogs right in front of us barking and real fearful. Then they [the guards] go, *"Don't take your eyes off the light."* Here we are trying to stand there and watch the light, and dogs right in front of you barking. *It's like, damn, how in the hell can you watch the light and you trying to figure out what this dog's fixin' to do. It's almost like damn the light, watch the dog. So that made a big difference.*

Coleman's friend Frederick Bernard said, "Well, they took us off the bus, they took us in, they put us on death row, which was two-man cells. They put eight people to a cell. They took our clothes, eight naked people in a cell. They opened the windows. The cold, damp air came through. White people would walk up and down. I don't know who they was, but they would walk through there and they'd call us names, and that was…" he winced and shook his head without completing his thought.

Mary Ann Nichols remembered:

We had about six white girls with us, maybe, I think it was. A couple of them had stayed at my house. They [prison authorities] *told them, "If you would stop and promise us that you are not going to march with these Ns anymore, then we will take you all back to Natchez." That didn't sit well with us, and it didn't sit well with them. They told them, no they weren't* [going to promise]. *We advised them not to stay because we worried* [if they stayed with us] *they wouldn't make it back to Natchez* [alive].

So we all stayed there, like cows in a stall with no privacy, no food, no way to wash or anything. Just in there. It just was…you know, just because you had to go through something like that because of the color of your skin? Sometimes we didn't think we were gonna make it back, you know. And they were doing the men so bad that finally…I think it must've been a trustee or somebody came around and asked us to do better [with being quiet and behaving] *because it was in October. It was cold, and they were shooting hose pipes on the men and things.*

Parchman survivor Herestine Pike recalls a young white woman called "Posey" Pike said, "What the man [at the prison] told her was, 'Why are you in here with these niggers anyway? Because you're free to do anything you want to do.' Her words were, 'I'm not free to walk up and down the street

with a black person, if that's what I so desire.' Now those were her words, and like I said she was the only white person there, and she happened to be in a cell with me."

L.J. Bell recalled:

Prior to us getting there, the first crew went up there. They forced them, they gave them laxatives. And when we went in, they had about twenty-one of us in one cell. They had us in a block where it was supposed to be hardened criminals. But they piled us all in a cell. It was nothing but cold sheet metal [on the cot]. And the fellas that were already there, they were taking turns going to the bathroom. Just as soon as one got off the stool, another one went. But they didn't give the laxative to us. I figured out later on they realized that our people who were already there were continuously using the bathroom; if they did that to us, then it would be a mess.

But they didn't give us any clothing. Anything. They made us strip down to our underwear. And we had to lay on top of each other to keep each other warm. And that is the way it was. They had fans that pulled in the outside air...in October. It was quite miserable.

They abused other people, but I can honestly say that was the worst part of it for me, just being cold and uncomfortable and all. But they did some other things to other people. We were treated like animals. They talked to you like you were an animal. And they would use these hardened criminals to bring you food....They would bring a strip of salt meat, a biscuit and molasses syrup. That's all I remember getting, whenever we did eat something, that's what you ate. Then they didn't furnish any toilet paper for persons that were using the commode. Even under normal circumstances you need toilet paper. But even after giving that laxative to people, no toilet paper.

Manuel McCrainey said:

Well, they gave us some laxative. They insisted that we remove our clothes. I don't know the number of people that was in our cell, but it had to be somewhere between eight and ten [in a cell meant to house two inmates]. *There were two beds in there like bunk beds, but they were stripped down. That's along with a commode and a face bowl. I thought that was totally degrading to take a man's clothes off of him and expose him to the world among other men.*

I might back up a second and say that I remember they turned, I say it's the air conditioning, but it got cold in there. I mean, it was truly cold. We

had no clothes, so we kind of bundled up. You know how you breathe and try to stay warm. That morning, I remember they'd given us coffee. I don't know about the rest, but they gave me a hard biscuit. The biscuit must have been about I'm guesstimating a week old. That's the way it seems because it was hard, hard, hard. I was frightened. I think I was so frightened I was in shock because a lot of this I do not remember. I was truly in shock.

Earl Turner remembered:

On getting there, the first busload people were telling us, "Man, you don't wanna get locked up in here. They gonna treat us bad." So we were brought around to the cell; we looked in there, it didn't have nothing but a bunk bed out of metal, concrete floor, three walls, but the wall over this way was a window. And they had the window open, and it was already cold. So we asked them, "When we gonna get the [prison] uniform?" They say, "You got the uniform that God gave you." I said, "Wow, man." Everybody went to talking, saying, "Naw, they're just teasing. They're gonna bring us some clothes 'cause they know we'll freeze to death up here." So by and by, that evening, it was late in the morning when we got there, and we say, "Well, maybe they're gonna wait 'til tomorrow." So by that time, the laxative started working.

In the cell was a commode, with no toilet tissue or no napkins or nothing. No soap or nothing. We went to hollering... The first busload of people was already doing their mess, doing their business, defecating or whatever, and we said, "Where's the tissue at?" About ten minutes later, they bought a roll of tissue. They say, "How many in the cell?" And they tear off...if it's six people in the cell, they tear off six sheets of paper. They say, "Use your hand and take that and wipe your hand." So we didn't have the proper accommodations for health purposes.

So we were so cold, and we couldn't sleep. So what we did...I forgot whether it was six or seven in my cell, but what we did, we rotated. Whoever sat on the end, go to the back end and the other man get the most cold, but we was huddled up like that, with the body heat trying to keep warm. So the next morning, one of the guards came along and said, "Y'all get a little breakfast in a minute." And he brought a biscuit, black coffee and hard eggs, and I can't remember did we have grits. But whatever they had, I didn't eat it because the only thing I tried to do was to drink the black coffee, and I think I dipped the biscuit in there and I ate that the first day. And then after that day, you had to eat, but it wasn't something that you desired.

Wilford Perkins recalled:

There were guards with guns down on us, and once we got in there, they made us take a laxative. That's exactly what it was, it was a laxative. And we asked them, "What's this for?" They said, "Don't ask any questions, just drink it." I said, "Man. Golly." So once we drank it, they just told us to shed off all of our clothing. So we had to take off all our clothing. I mean everything.

Once we did that, they took us to this holding cell. Matter of fact, the holding cell became our area where we were gonna be. So after we got in there, it was about twenty to twenty-five of us in one cell, all butt naked, and they had one commode there, and once we'd started, there was just a chain reaction. Everybody was getting sick and everybody was using the bathroom. It was just disgusting. It really was, and everybody in there at the same time, and once they were making a lot of noise because they wanted to get out so they decided, they said, "Okay. Tell you what we gonna do." They turned the air conditioning on us, and we're already naked. Then they threaten us to put water on, but the air conditioning itself was terrible, and they kept it on for the whole time we were there. In order to stay warm, we had to huddle. We weren't thinking about no man features or nothing like this or whatever, we were just huddling together just to try to keep warm, and it lasted for four days for me. It was terrible, and until this day, I will never forget that as long as I live.

Helen Smith White recalls being terrified:

In my mind, I'm so afraid because I had a five-month-old little boy that I adored. I had a mom and a dad that was my world. I was an only child. All I could think of was, "Lord, they never going to see me again. And I'm never going to see them again." This happened day after day. They would bring us food. Slide through an opening or sometime they would just throw it in the cell. And it wasn't anything decent to eat. It was something like bacon or biscuit, and it was moldy. You couldn't eat it. They would give us water sometime. Sometimes not. To me it was pure hell and torture. I just kept thinking, "What was my mom [back in Natchez] thinking?" I know how much she loves me, and I know she was wondering where was I because we had heard that no one really knew where we were. In the midst of all of that at night, in the coldness, they had broke out the windows they had up over that door. They had glass. It was like they had broken some of the glass out so that the coldness could come in.

Again, Ronald Coleman said:

Then they start marching us [from the buses] *into a building. When we got in there, we found something else that was very much unexpected when they gave us this big old cup. They made us drink out of this cup, not knowing what was in the cup. Then they told us we had to undress. So naturally, we had to do what was ordered of us. They took all our clothes from us. They just started telling us to, "Gap your [butt] cheeks. Gap your cheeks." We like, "What the hell? Gap your cheeks? What? They want us to do that?" So they wanted to look up our rectum. We had to drink this cup of laxative, bend over naked and gap our cheeks as ordered.*

Now, we go into another phase. They start separating us like five to six maybe nine person at a time and taking us off to these jail cells. Now it's cold, and no clothes or nothing else. They start filling up these cells with us. I forgot who all was in the cell because it's been a while back. They start rolling off toilet tissue, maybe four or five squares per person. Here we are in the cell anywhere from five to maybe eight people in the cell with this toilet tissue, one toilet. I think it was maybe three bunks in there. So we had to share a bunk, walk around, very humiliating, naked with the toilet tissue. Now hours later, whatever they gave us in that cup started working, and it was nothing nice then because everyone would start having bowel movement or whatever.

Then they said they were going to bring the water hose down and hose us down if we don't be quiet. This was a very, very humiliating situation being a teenager in a cell with other guys, you naked, cold, no mattress, no nothing, no cover. I'm wondering, "Damn, this is happening. What's happening with my mom?" Because if I'd been by myself, it would've been a totally different mindset. So now I'm getting uneasy about what's going on with my mom. We kept hearing rumors they doing this to the women. They're doing that. My mom is in there. I'm like, "Hey, damn what's happening to me. What they gonna do with my mom?" At the same time, the guards coming around telling us to shut up. They gonna kick our ass and everything else.

The women were in a different cellblock but in earshot of the men. Women we interviewed said they were allowed to keep on their undergarments and even some socks. Even so, they were subjected to the same unheated cells in the October chill and the same inedible food: hard biscuits and cold coffee, for the most part.

Beulah Fitzgerald.

Beulah Fitzgerald recalled:

Well, we went on in there and the floor was dirty. The toilet was dirty; it didn't have no seat on it. The face bowl looked like it hadn't been cleaned in a year or so because it was all brownish looking. And then after we got in there…maybe an hour…two ladies came with a jug. Looked like milkshake, but you know it wasn't. We didn't know at first it wasn't milkshake. And they had one cup, a Styrofoam cup, and they filled it up about halfway and gave each one us [the cup to drink]. *"Take yours, you take yours, you take yours."* You had to drink all that stuff that they give you. And out of that one cup. And then the other lady gave you four sheets of toilet paper. That's all you had. They kept going on up the line [of cells] like that for us. They had a bunk, one bunk in there. Some people got on the bunks and some had to get on the floor. No mattress, no nothing.*

I wondered how long is it that I'm gonna be here. Because I thought maybe they would send the buses back to get us. But that didn't happen. Inside the cells, the young men and women strained to keep each other's spirits up. They prayed, talked, cried, sang and huddled in the cold.

Again, Delores Young McCullen, remembered:

I'd just like to add that the cell condition was just deplorable. They fed us maybe two meals a day. I really can't remember because I don't actually recall eating too much at the time because there was so much noise. And when I mean noise, there was so much cryin' and whinin' and prayin'. It was just constant all day and all night. Then you could hear them on the other side [of the cellblock] where the men were. And I don't know who they were beating, but you could actually hear the striking.

We were thinking we're probably getting raped. It was just like, "What in the world is going on in there?"

So I consider myself one of the lucky ones because I had worn a pair of, at the time we call 'em stirrups, the pants that hooked onto your feet. And I had on a pair of, what we call at the time leotards; today they call 'em tights. And they had my feet in. So when they told me to pull off my socks,

I told 'em I didn't have on socks. So the guard said, "Well, you gotta keep 'em [the leotards] on." So I was a lucky one.

A lot of the women got sick. You know, the stench and all of that. And like I said, it was just one bed, and those who had been there earlier, I don't know how long, two or three of them, they were on metal beds. I had to take the floor. And we slept on the floor and we sat on the floor all day. And morning, like daybreak, we would get an inmate and they would bring us breakfast. They fed us, but you couldn't eat it. The grits were like a brick. And the poor inmate, they looked like they had been beaten. Damn, they were crippled. They fed us, but it wasn't anything good. A doctor was seen one time, but all he did was dole out some aspirin.

Terrified. I would say to myself, "Oh my God, where is my father? Where is my daddy?"

The Parchman Ordeal sufferers were not allowed phone calls or communications with anyone in Natchez. Many said in interviews they didn't know if anyone in Natchez knew they were in Parchman Prison and, if so, that they were being mistreated. Meanwhile, NAACP leaders, church leaders and family members in Natchez were making plans to get the young men and women home.

L.J. Bell said some "even went into shock," but few of the survivors recall seeing a doctor come through the cellblock.

However, gawkers were allowed in. "We saw people in civilian clothes walking through calling you names. I guess they were politicians and whoever. They'd come through saying, 'Look at the monkeys…,'" said Frederick Bernard.

Ronald Coleman said, "If they were doing the job to make us feel less than what we were, they did a great job at it."

FREE AT LAST

They say, "You're going home. You're going home." I said, "Thank you Jesus, thank you Jesus." All I heard was "going home." I wanted to go home. I was so weak I could hardly stand up.
—Delores Hence, Parchman Ordeal survivor

In October 1965, as nearly 150 young men and women from Natchez suffered in degrading, miserable and tormenting conditions four hours away in Parchman Prison, scores of relatives, supporters, clergy and civil rights activists were working to get them back to Natchez. Authorities in Natchez or at the Mississippi State Penitentiary in Parchman had made no arrangements to transport them back to the city. In fact, many of the young men and women really didn't know why they were sent to the prison instead of being released in Natchez. After all, they just wanted to peacefully march to show their support for civil rights and voting rights, even though many were not yet old enough to vote. For the most part, though, the imprisoned young people were unaware of what steps were being taken for their release. Wilford Perkins asked:

"What have I done to deserve this? And why don't my mom know about this? Why didn't they let me make a call or tell somebody where I was?" That went through my mind and actually, for a moment there, I hated all… excuse the expression…I hated all white people, I really did. That's the first time I ever felt that way about hatred because I was brought up not to

hate anybody, to love everybody, but that actually went through my mind, the hatred. It really did.

Georgia Mae Sims sensed their release was nearing. "We should have known something was up because the day that they came and got us, they gave us a meal—pork chops—that wasn't sour. They gave us pork chops. Maybe they figured we wouldn't tell what they did to us [by serving a nice meal]."

As individuals arrived from Natchez with papers proving they had paid the bond fee, prison authorities would holler out names of those arrested, who still wore either little or no clothes. The survivors said the cellblocks were chaotic, noisy and frightening.

Alice Lewis recalled:

I was angry, sad, hurt. Every negative that you can think of, I went through it, but most of all, I was scared, 'cause like I said, I was afraid that they would put us in a mass grave either before we went [in the prison] or after we left. When we ready to come back to Natchez, I just thought it was an end for me, and to the very end, I wasn't satisfied until I walked off that bus [in Natchez].

Hence remembered:

Well, I didn't really know [we were being released]. The man, guard or somebody, came in and called my name, and so he said, "You're going home." I said, "Oh thank God." So he marched us outside to the yard, and in the yard, there was a lot of other people from Natchez. We were lined up, like they do on, you see on TV and the movies, lined up and everything, and they say, "You're going home. You're going home." I said, "Thank you Jesus, thank you Jesus." All I heard was "going home." I wanted to go home. I was so weak I could hardly stand up. But we were all there lined up together, and then they would call people's names who were going home with certain people. The NAACP in Natchez, they had sent different people up to bring so many home. And they told me that I was going to go home with Wharlest Jackson. And I did. He brought me home.

Hence sighed and grinned at the thought of returning with Jackson.

Wharlest Jackson was a military veteran and an employee at Armstrong Tire and Rubber Company, where George Metcalfe worked. He and

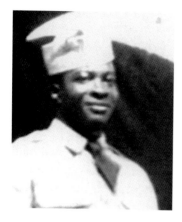

Left: Wharlest Jackson. *Courtesy Natchez Museum of African American History and Culture.*

Below: Authorities look over the bombed truck of Wharlest Jackson. *AP photo. Used with permission.*

Metcalfe were friends, both officers of the Natchez chapter of the NAACP, and they worked to register African Americans to vote. Also at Armstrong were workers associated with the Silver Dollar Group, the Klan members who had attempted to kill Metcalfe just weeks before the Parchman Ordeal in 1965. A year and a half later on February 27, 1967, Jackson was killed by a bomb attached to his 1958 Chevrolet truck as he headed home after his shift at the tire plant. He was thirty-six years old.

The Natchez Police Department arrived on the scene and found Jackson's truck almost blown to bits. The blast blew out the top of the truck, the front

and rear glass, both doors and the hood. Although no arrests were made, the killing—similar to the attempted assassination of George Metcalfe—is strongly linked to the Silver Dollar Group, according to research by investigative journalist Stanley Nelson. Jackson is considered one of the least-known but equally brave martyrs of the civil rights movement. His name is listed among the forty-one "Civil Rights Martyrs" on the Civil Rights Memorial in Montgomery, Alabama.

The Natchez community was shocked and appalled by Jackson's murder. Charles Evers and the Natchez NAACP organized a protest, leading two thousand demonstrators to watch the changing of the shift at the Armstrong plant. From the Armstrong plant, the demonstrators marched to the place where Jackson died and then to Rose Hill Baptist Church, where they had an hour-long meeting. Even then-governor Paul Johnson, infamously hostile to the NAACP, called Jackson's murder "an act of savagery which stains the honor of our state," according to records at the Northeast University School of Law.

But for Hence at that moment in October 1965, Jackson was her guardian angel. Many of the young men and women who were involved in the struggle in Natchez admired Jackson and respected his leadership.

For teen Delores Young McCullen, the moment of release was, well, overpowering:

> And when I turned that corner and saw my father, it was the best thing in the world. I was out of there. I was tired, hungry, sleepy. I was just, I don't know if amazed is the right word, but I was just like, "Why?" You know, are black folks…what's the word?…Are we considered non-human to be treated like this? I just didn't understand why, you know. To go to this extreme to be tortured and talked to and treated like that. You know. That was worse than you treat an animal.
>
> Yeah, when I saw my father there—I just wanted to throw this in here too—they were subject to a lot of ridicule when they came to get us. They were searched and they were talked to crazy and stuff like that. But then we had the bond [a bond paid to Natchez law enforcement authorities for the release of those imprisoned at Parchman], so they had to let us go. I remember my dad sayin' how rude they [prison authorities] were, but we got away.
>
> The ride was scary coming back, too, because we were on a long dirt road. And it was just us in the vehicle. And you just never knew when they were gonna come after you. Because we've seen all these shows, you know,

where you're ridin' along on the highway and the Ku Klux Klan get you. And you know, we were afraid. I didn't feel good until I got home.

That sense of fear rode with many of the young men and women on their journey from the prison back to Natchez. In 1965, a car, van or bus of African Americans on a rural road was a target for attack by white groups. We saw how the Freedom Riders' buses were stopped four years earlier and the riders assaulted. But all of the young men and women made it safely back to Natchez.

Alice Lewis said:

We were singing our freedom song on the bus [home], *and when we went off…my favorite song was "I Came from Parchman with My Mind Set on Freedom." That was one of our songs. "I woke up this morning with my mind set on freedom," and we did our march set on freedom, so when we got off that bus* [in Natchez], *we were singing, "We Came from Parchman with Our Mind Set on Freedom."*

Ronald Coleman recalled, "There were rumors that they [folks in Natchez] were coming to get us. We would only be there until the next day. They were going to come get us. This is what we heard when we left the church: 'Well, we'll be there to get you up. If they lock you up, don't worry about it. We're going to get you.'"

But what the young men and women didn't realize while they were incarcerated was that Charles Evers and the members of the NAACP in Natchez, along with other African American leaders, church officials and family members, had begun an effort for the young folks' release. Evers said that as the buses rolled out of town headed for Parchman Prison, he knew what he had to do: "get on the phone and call the governor and the [Natchez] mayor…get them out." Evers said he learned what was going on in the prison from periodic updates from a prison employee he knew. "That old man…he kept us informed. It was terrible what they were doing to them."

With the arrests and transports occurring on the weekend, it was difficult for family, friends and concerned individuals in Natchez to get information on what they needed to do to get the young people released. Compounding the trouble for Evers and others was the fact there was no arraignment in court on the charge of parading without a permit, which then was a hastily crafted city ordinance meant to prevent any marches—peaceful

or otherwise. Arrest records show that the arresting officer was listed as "Chief JTR," meaning Natchez Police Chief J.T. Robinson, who personally oversaw the roundups outside the churches. It appears, because we have been unable to obtain substantiation, that someone in authority set a bond on each of the young men and women and that paying the bond locally—very likely at the Natchez Police Department—and obtaining proof of payment was the only way to secure their release from Parchman Prison. Many survivors mentioned that the bond amount was $200, but no records exist to reflect that amount. In fact, we were unable to obtain any records of the incarceration at Parchman from authorities. And authorities at the Mississippi Department of Corrections refused our request to travel to the prison for our own research.

So by car, van and bus, the Parchman Ordeal survivors were brought back to Natchez.

Ronald Coleman said:

I was glad to get out of there. I was hurt. I had been degraded. I wondered if this cause would be recognized. I wondered how would I be when I get back home. Now, you gotta go back and face friends, neighbors, everything else. Everyone knows. "Hey, y'all been naked. They gave you toilet tissue. You had bowel movement." If they were doing the job to make us feel less than what we were, they did a great job at it.

Alice Lewis recalled, "Zion Chapel [African Methodist Episcopal Church], yeah. That's where they brought us back to, and that's when we were able to sing.…There were people coming up and getting their loved ones [from the prison] one at a time, one at a time." Lewis, though, was among the survivors who returned by bus provided by the Natchez chapter of the NAACP.

Delores Young McCullen said, "The days following…I remember my mom kept us, my brother and me, out of school for about maybe a week. I wasn't scared, but I was just traumatized. I was like, 'God, what did I just go through?' And she just kept us at home and fed us and loved us, and it kind of went away."

Georgia Mae Sims said:

I learned that not all whites are bad but not all blacks are good. And I'll tell you why I say that. Because like I said, what we went through being taken to Parchman, nobody ever asked me [when we returned] what

the ordeal was about. What was it like? How did they treat you? And they knew who had went up there. And when I say "they" I'm talking about people who was over the civil rights movement here. And I'm not trying to dog them out, but I'm just telling you the truth from the eyes of an eighteen-year-old.

Charles Evers admitted:

They're right. And I take blame for part of that, too. We just never did meet them and greet them. We really didn't know they were coming back, to be honest and true. I'll be the first to admit that we didn't meet them and greet them like we should have. I'm first to admit that. But just at that time, we weren't thinking about no meet and greet. We were still so busy fighting bigotry and hatred among the white folks. And I apologize, as one of the leaders in that movement. I hope they didn't hold that against us, but we were just so busy fighting racism at that time that we didn't think enough of our own race to take care of them, I guess.

Many of the survivors said they came back somewhat shattered emotionally and sick physically. They were trying to figure out what had happened to them, why these things had happened to them, and the fact that they seemingly were just allowed to seep back into the community rather than be welcomed back as the triumphant return of the fighters. By varying degrees, the young men and women had their own difficulty adjusting. The local white-owned newspapers did not report the survivors' incarceration at Parchman and their release. We learned scores of whites, and even African Americans, were surprised and even shocked to learn of the ordeal when we released the film *The Parchman Ordeal: The Untold Story.*

"Yeah, it took a while to adjust," said Stewart Foster. "And one more thing, in that prison, there was a scent or odor. It stayed with us almost about a month, almost. Two or three weeks before that passed on. There was a little odor after we…Well, it was in the Parchman Pen itself, but it took a while for that to wear off."

Mary Ann Nichols said, "I was happy. I was sick, but I was more glad because I missed my family. I had missed my child, and I know it was hard on my mom for her to have two children there, plus cousins. You know what I'm saying?"

Delores Young McCullen recalled, "I gained a lot of knowledge from it. I really realized, like I said earlier, I had no idea how much hatred people had

for the black community. And I realized that during that time. But overall, I don't know if it affected me in a good way or a bad way. I just gained a lot of knowledge from it."

Alice Lewis said, "Like I'm telling you now, because the older people wasn't participating, and after that, including my uncle, who I was living with, I was…treated with the highest respect, highest admiration. I mean, he went all out for me, because he knew what I did was for him. I sacrificed my life going up there for him, his freedom, his civil rights…"

Earl Turner said, "I can tell you this, once I came…I was frightened in Parchman, but when I got out and got back to Natchez was more eager to participate than ever [in marches and protests] because of the way I was treated." Turner was among several of the survivors whose fervor for action only intensified after returning from Parchman. Others returned to school or work or even left Natchez.

Many Parchman Ordeal survivors interviewed said that although they didn't receive recognition when they returned, their experience seemed to spark efforts in the African American community to step up the fight for change.

Next, we will see how the Parchman Ordeal affected those who suffered through it, the difference they made and the reconciliation on the fiftieth anniversary of their arrests.

RECONCILIATION AND RECOGNITION

I was shocked. I mean, shocked just doesn't go away overnight. It's something that stays with you for a long period of time. Shock stayed with me until I went through two marriages. I asked myself a question: is it me? There can't be that many bad ladies in the world until I met my present wife. When I met her, she immediately said, "You know, you need help." At that time, I got therapy. A lot of this came out.

—Manuel McCrainey, Parchman Ordeal survivor

A mixture of glee, shock, dismay and anger accompanied the Parchman Ordeal survivors as they arrived back in Natchez. As Charles Evers said, there was no special treatment for them—no mass meeting, no chorus of gratitude, no therapy. Astonishingly, the young men and women never had their day in court. Apparently, the arrest records were filed away and discovered decades later with no adjudication listed. No officials are still alive to definitely tell why, and we did not wish to speculate.

Although the survivors weren't specifically told to do so, the young men and women were expected to blend back into the lives they had prior to being imprisoned even though the scars—emotional and/or physical—remained.

"I was hungry. I felt nasty. And didn't look too good. My hair was not combed. All I could think about was washing Parchman off," said Margaret Willis Brown Morris.

For Ronald Coleman:

I was glad to be home. I was safe. I felt safe with my mom being there. The reception, if I could remember…if there was a reception, I don't remember nothing. It was no parade welcome home thing. Things kind of quieted down. A lot of people didn't march because of the fear that they're going to lose their job or get fired or things happening to their family. Well, there was an emptiness to me because there never was a big thing as pat you on the back, "We're proud you went. What you did was accomplish something." I never did receive that.

I stayed around until I graduated. My sister [Daisy] that was arrested had an accident. She drowned. My mom went on to doing what she was doing. I was a senior that year. I had an accident. I went in the hospital, stayed there for a good while. But my whole prayer was, "I'm getting out of Natchez. I don't want to be here. I have no ambition of staying here in Natchez." They told us, "If you lie on your [job] application, you're going back to jail. You'll lose your job." So being in prison, and you do an application for a job, and they ask you have you ever been arrested, they had put fear in you enough to say, "You can't get the job because you been in jail. You've been in prison. You were in the civil rights movement. We're not going to hire you." From that point, I knew the opportunity of staying in Natchez was next to none. So I said my next march will be marching out.

Like Coleman, Wilford Perkins had plans that didn't include Natchez:

Once I got back here, I said, "I need to do better for myself. I need to get out of Natchez." And I worked on that and worked on it until I was able to do so. I left here in 1967, and I never returned again until 2001. So it was just good to be away, and once I got away from Natchez, you could see the difference [in the way blacks were regarded and respected] *right off the bat, and when the other race, the white race, came up to me and talked to me, I thought it was strange but after a while, I got used to it because it was something different for me because it was always black on black here in Natchez but you didn't intermingle with the white race at all. Period.*

Georgia Mae Sims said, "And when I came back to Natchez that night on the bus and we got off of the bus and went into that Methodist church right there on Martin Luther [King Jr. Street]…well, it was called Pine [Street] then…we all went in there and had another meeting and everything. But

really and truly, no one came around to ask us what happened to us. At least they didn't come to me."

Margaret Willis Brown Morris said, "I didn't get out the house for two weeks. Scared I was gonna get arrested [again]."

Earl Turner said:

> *Life turned out to be pretty stable because I was just a high school graduate and I worked various jobs in Natchez, from Head Start programs to work at the drugstore, I would deliver. In 1973, I was the first black insurance agent in Adams County. I was employed by National Life Insurance Company in '73, and then I transferred in '75 to Memphis, Tennessee, where I stayed with National Life, which American General bought National Life out and I stayed with them 'til 1989, which was the year that I did insurance. And I was married, have three children and I'm divorced now, single parent. But all my kids are grown.*

Georgia Mae Sims remained committed to the struggle.

> *If I could endure something like that, I could do anything. And I came back home. I still worked with the NAACP with voter registration and stuff like that. Went up to Fayette because at that time that's where they were trying to get people registered up there. I worked with them to do that, went into the woods and neighborhoods, and white men was driving by in their trucks with the guns up in their racks and everything. And black people whose door you knocked on, they were slamming the door in your face because they were afraid. But I went through it because we had to do what we did. We had to get black people registered to vote if you wanted a change. And then, like I said, I didn't hear anything from anyone about what happened to us when we went to Parchman. And I didn't leave Natchez until 1968, January of '68, because I had put in for the Job Corps program. They had an opening in January of '68, and that's when I left Natchez. I went to Oklahoma for a year. Then they had advanced course, and that's how I wound up in San Francisco, and I stayed there for thirty-one years.*

Edith Jackson said:

> *Well, when I came back, like I told you, I was working at Morgantown School and was one of the cafeteria workers. Well, to me I always like to*

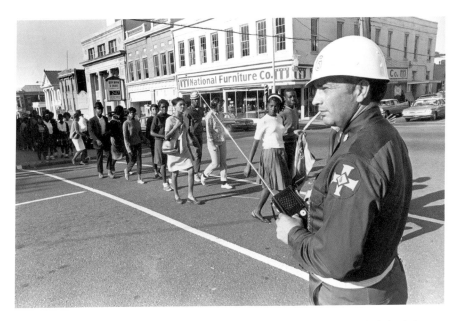

Jack Seale, who identified himself as a major in the security guard of the Mississippi chapter of the Ku Klux Klan at Natchez, watches as some one thousand civil rights marchers pass in downtown Natchez, Mississippi, October 30, 1965. Seale said that he and fourteen other KKK security guards were on hand to "keep the peace" during the demonstration. *AP photo. Used with permission.*

> *pray. Now that's one of my issues. And I just wanted to be in the Lord and savior Jesus Christ's hands. And I went right on back to work. And you know when you get back to work or whatever it is, they're looking at you, and I didn't know whether they were going to let me stay there or not. And well, I didn't worry too much about that part on that.*

Many survivors who remained in Natchez resumed marching, helped with voter registrations and worked to change the community.

Stewart Foster said:

> *We got more active in civil rights; we didn't miss a meeting at all. And what I'm trying to say, things in Natchez got better. We could see the changes, racial wise. The law enforcement people stopped bothering us, and we almost could go and walk into most any place. There came a change behind that, no joke. There came a change behind that ordeal. But after that deal, things opened up. We started getting jobs, we…different ones, all different friends. These plants and things start hiring us.*

Charles Evers said the marches took on a more assertive tone after the Parchman Ordeal, and boycotts of white-owned businesses increased.

And a funny thing about marching nonviolent, it's one hell of a weapon. We never had no guns, we never had no sticks or nothing like that to fight. We just marched with our bodies. And we began to overpower the white power so we could begin a change. And in Natchez, things changed almost instantly when it came to respecting us in the stores, in the businesses and on the streets. And we found that was the thing that did most damage, I believe, was boycotting all the stores that disrespected [African Americans]. *Finally, I guess, we started hurting them in their pocket.*

For example, there was a time after Parchman and before Christmas when African Americans boycotted stores and celebrations. "No lights, no toys, no nothing, and for that Christmas, I think can honestly say 90 percent of Natchez blacks participated in Black Friday [by boycotting the stores]," said Alice Lewis. "We didn't have a Christmas, and that closed some businesses down because of that....That made me feel good, 'cause we let the people know we mean business because they were discriminating against us as we came into the stores. A lot of people [today] don't realize that."

Former sheriff Tommy Ferrell commented, "How did they bring a community like Natchez to its knees? They did it through an economic boycott, and it was successful. And there were a lot of changes, a lot of concessions after that. And so, the old saying of hit them in the billfold, it worked. It worked for them."

He added:

We've learned so much since the civil rights era. You'll never see that type of incident occurring again, especially dealing with a state penitentiary. If nothing else, they could have been processed right here in the City Auditorium. But the mindset was to get them out of the community, get them out of the community so that whatever civil unrest was being created would stop, for the protection of the community. Not necessarily a rightful or good decision, but that was the mindset at the time.

Journalist Stanley Nelson concurred about the success of the movement that, he said, changed not just Natchez but also the entire South:

Well, there's no question: look what happened after that bombing [and Parchman Ordeal]. Look what happened; it really gelled the civil rights movement I would say in Natchez. It resulted in the economic boycotts of Natchez that put the business community on its knees. Of course, it ended up with the Parchman event, but the negative publicity of that also was nationwide. So all of the reaction to it outside of this area as far as nationally is concerned, is it simply highlighted what a dangerous place this was but that the civil rights movement was not going away. To me, the Metcalfe bombing gelled the civil rights movement.

In a nutshell, the bombing of Metcalfe was sort of the rallying cry of the civil rights movement, and it resulted in the majority of the demands Metcalfe and the NAACP had developed in the spring of '65, the majority of those demands were met.

However, in 1972, the United States Court of Appeals Fifth Circuit issued a ruling that established culpability by authorities responsible for the arrest and incarceration of the young men and women from Natchez. The court ruled that Natchez authorities violated the civil rights of the young men and women by not properly following due process rules by "failure to bring demonstrators before a magistrate." (None of the survivors reported appearing in any court proceeding or seeing a magistrate or judge prior to being taken to Parchman and during and after their incarceration at Parchman. Also, our research indicates that none of the arrest records of the Parchman survivors and those who were arrested but were not taken to Parchman was ever adjudicated or vacated.) The court ruling also placed blame for the imprisonment squarely on the shoulders of Police Chief J.T. Robinson, who, the court said, "was in complete charge at the auditorium. He did not go to Parchman but arranged over the telephone to have defendant C.E. Breazeale, the superintendent of the Parchman Penitentiary, receive and detain the arrestees pending their making bond." The ruling, though, split liability between Robinson and Breazeale, with Robinson determined to have violated rights of the young men and women but not responsible for their treatment at Parchman, which the court blamed solely on Breazeale. Court documents affirm that those who were incarcerated at Parchman were subjected to "cruel and unusual punishment." Breazeale also was cited for similar treatment of the Freedom Riders four years earlier.

However, much to the dismay of the Parchman survivors we interviewed, the court did not order reparations or damages for their suffering, a matter

that still rankles survivors more than a half century after the ordeal. By the time of the court's ruling, the statute of limitations for such reparations or damages may have expired, according to court sources. Neither Robinson nor Breazeale was still alive at the time we prepared this text.

WEEKEND OF RECONCILIATION

It wasn't until 2015—fifty years after the arrest and ordeal—that those who were imprisoned received any recognition. In fact, many had pushed the memory well back in their minds, and some even shut the door on what had happened.

In 2015, the City of Natchez, the oldest settlement on the Mississippi River, was in full preparations to celebrate its tricentennial, and racial reconciliation was one of the myriad themes to commemorate the 300th anniversary of the city's founding. Also, our team of local historians and documentarians was engaged in an oral history of the Parchman Ordeal survivors for the Mississippi Humanities Council and the University of Southern Mississippi's Center for Oral History and Cultural Heritage. Thus, the need to honor the survivors rose to a level never before considered.

A weekend of reconciliation and remembrance was developed for October 2015. The first event was a prayer and song service at Beulah Baptist Church, the very church at the center of the civil rights movement and the church where Charles Evers fired up the young men and women fifty years earlier.

With hands clapping, arms swaying and voices singing, people filled the small church with joy. Familiar songs from the civil rights era were sung to re-create the atmosphere of a half century ago: "We Shall Overcome," "Ain't Gonna Let Nobody Turn Me Around" and "Amazing Grace."

"Nineteen sixty-five was a turbulent year in our nation's history," said Darrell White, director of the Natchez Museum of African American History and Culture and one of the speakers at the church program. "Members of our community…many of you sitting among us today decided you were not going to continue to accept the abuses that had been inflicted upon our community. We're going to take a stand, and the subsequent actions led to the reason we're in celebration today."

Another speaker, the Reverend Melvin White, pastor of Pilgrim Baptist Church, bowed his head. "Let us pray. Dear eternally and gracious Father,

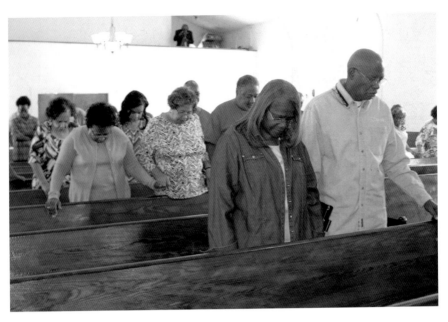

Beulah Baptist Church weekend of reconciliation service for Parchman Ordeal survivors.

we thank you now for the assembling for all those who came to share in the commemoration of the fifty-year anniversary on behalf of those who stood up for justice."

As the survivors left the church wearing their "I Survived Parchman" T-shirts, no authorities were there to arrest them this time. So they took up the march denied to them fifty years earlier. Those who had stepped from the church and been shoved onto buses a half century earlier raised their heads high, some using canes and some with walkers. They joined arms and sang and marched a half block to the corner of Beulah Street and Martin Luther King Jr. Street. There they stood singing "We Shall Overcome" as the daytime traffic passed by. It was a great start to a weekend filled with terrific moments, the highlight of which was the fiftieth anniversary banquet at the Natchez Convention Center.

Dressed in church finery, the survivors and their family and friends were fêted with music, prayers, speakers and awards. Several of the survivors offered their renditions of the ordeal. But the climax arrived when Natchez mayor Larry L. "Butch" Brown read a resolution on behalf of the City of Natchez:

Parchman survivors and friends gather on the steps of Beulah Baptist Church after the weekend of reconciliation service.

Parchman survivors and friends march outside Beulah Baptist Church during the weekend of reconciliation.

Parchman survivors gather with their plaques honoring them for their courage. Presentation was made during the weekend of reconciliation banquet.

I was away at college when this event took place. Of course I heard about it like everybody else, and I've heard about it for the many, many years in those fifty years. I was challenged to say that the City of Natchez is sorry, and I was challenged to make it a direct statement, not something that is innocuous and has no real meaning....I think this is something that has yet to be said anywhere else in our state, and in very few places across the United States. With that I will read you the resolution.

This is the official resolution adopted by the Mayor and the Board of Aldermen. This is the document that will rest in the archives and the minute books of the City of Natchez from here to eternity. If you will bear with me and listen carefully, this is something that I think is most important and unique in the history of the struggle:

"A resolution of the Mayor and the Board of Aldermen of the City of Natchez, Mississippi acknowledging the 1965 Parchman Ordeal.

"Whereas the City of Natchez, Mississippi, must stare down its shame for the mistreatment of hundreds of innocent, black Natchezians in what has come to be known as the Parchman Ordeal, and wherein everyday, citizens were arrested...for civil disobedience, and hundreds were shipped against their will to the maximum security unit of Parchman Penitentiary without due process, where they suffered abuse and horrific conditions, and whereas in that ordeal, the injustice inflicted on those citizens were the result of irrational hatred and a failure of government;

and whereas the wound created by the Parchman Ordeal is still unhealed these fifty years later; and whereas the mere passage of time will not heal it altogether; whereas that it has been said injustice must be exposed with all the tension its exposure creates before it can be healed; now therefore be it resolved that for fifty years, the City of Natchez failed to acknowledge publicly the disgrace of the Parchman Ordeal; that in that ordeal, the City failed its citizens and failed the principles of all the nation; that even though it has been a long time coming, it is not too late to recognize and to apologize to those true heroes of Natchez who bravely endured degradation in advancing the cause of equality before the law; that today, here, the City acknowledges its role in the Parchman Ordeal and apologizes to the hundreds of citizens who suffered those injustices; that as the City prepares to begin its tricentennial year, it will shine a light on all parts of its past, both good and bad, so that its future may be one lit with unity in pursuit of liberty and justice for all."

I'm very proud to present this resolution of responsibility and apology for that fifty years waiting for the same.

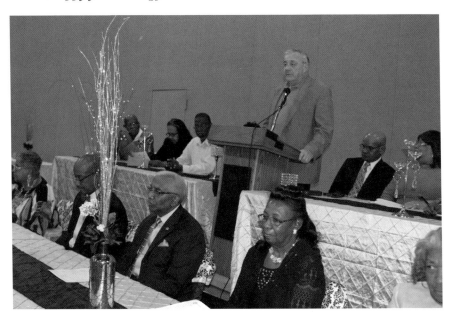

Mayor Larry L. "Butch" Brown delivers the resolution of apology at the weekend of reconciliation banquet.

After the mayor read the resolution, former mayor Phillip West, the first African American mayor of Natchez since Reconstruction, said, "As the resolution was being read…a tear wanted to come down my face because if you were living during the time…this particular time…as most of us who are here would have been, we understand what that means and how far we've come. We aren't perfect, but I can guarantee you, we've come a long, long way."

Parchman survivor Herestine Pike, who attended the banquet, said, "They [banquet planners] got all of us together…those who were still living. They had it decorated so nice at the convention center. When you thought about how bad it was when they took you to Parchman and how hard it was…then to see this [banquet] was so nice. They went far and beyond to make it look elegant."

As for the city's apology, Pike said, "The things that they said [in the apology] and how they were sorry was special. Just the idea that the city [leaders] said they were sorry, especially since it wasn't them who did that to us. It brought a little tear because it made me feel like, okay, we were wrong, they [officials in 1965] were wrong, but we're sorry because you shouldn't have been treated like that."

In 2017, city and county officials took steps toward a permanent commemoration of the ordeal. Many favor a marker at the Natchez City Auditorium with the names of the survivors and possibly names of those who were arrested but were not taken to Parchman.

Pike said, "One of the greater things that I've done was to go to Parchman. I told my grandson, 'I might be dead and gone but they're going to put a marker up and your grandmother's going to be on that marker. I don't know when they're going to get it up, but it's going to happen.'"

PART OF HISTORY

As we learned, the Parchman Ordeal survivors agree that life for African Americans improved after their ordeal. But what of their role in the larger picture—their role in history?

Georgia Mae Sims said, "You know, when I think of history, I think of Martin Luther King and people like that. When I think about it now, especially since you all wanted to make an oral history of this, I guess in a way I did my little bit, too."

Beulah Fitzgerald said, "I wouldn't want to do it over right now. But I'm not bitter about doing it."

Mary Brown reflected:

Mary Brown.

I think about it now sometime, and this emotional feeling that comes over, thinking about the things that blacks have to go through to be able to make it in this world.

I've told them, a bunch of friends of mine and classmates that I went to school with, and they didn't believe that the ordeal about the Parchman trip, and I just told them what I could remember about it and they'd say, "You went to Parchman?" I'd say, "Yes, I went to Parchman." And they were saying, "Well, I don't think I could have done that," and I said, "Well, you can do some things that you think you can't do."

I learned that sometimes you feel like you can't take some things, but with the Lord on your side, you can take some things, and you know you can go through some things and try to help make it better for some others as you pass through this life.

What should people know about that time? They should know that blacks have had to go through something to get to where we are now. They should know that it wasn't easy, that some of us were beaten, some of us were sprayed water on, some of us were laid out like slaves—well, they used us as slaves back in the day—and they had a lot of problems with trying to live and get through their lives. Some of them have passed on, but they have made it a whole lot better for some that are coming on today.

Margaret Willis Brown Morris said, "I look at when I was marching, really, for the right to vote, I wasn't old enough to vote. And then now they are, so what's stopping you? Get up and go vote. You don't have to tell me who you vote for, just go vote."

She emphasized, "Just don't be too afraid to stand up. Stand up."

Delores Hence said:

Oh yes, indeed. I feel I'm a part of history. Like I said, I'd do it again if I have to. And I don't think I'd cry either, this time. Yes, indeed, I feel that I made a difference. Made a difference. Oh, I'm just thankful that we did

have the little movement that we did in Natchez and made things a little better for us. And the relationship between the blacks and white is not what it yet should be, but it's much better than it was back in the '60s.

Wilford Perkins said:

Yes, I am [glad to have taken part]. *I know I'm a part of history for the simple fact that, without the marches and things to get everybody started, I don't think we'd be as far advanced as we are now today because of those simple marches that you set out to do something and everything gets done. So eventually, we did get the voting right here in Natchez, and eventually we did get to eat down at McCrory's. Everything changed, and they changed the signs from white to color. There were no more signs as far as that's concerned. I think we accomplished a lot just by that little march we did.*

Stewart Foster reflected, "The way I feel now, I don't really feel a real grudge, hardly. It was just an ordeal that, during the time, that something needed to be done, and we had to sacrifice ourselves, our bodies or whatever it took, to make things better for our race."

Although he did not go to Parchman, the Reverend Clifton Marvel has ministered to many of those who were imprisoned, both in his role as a pastor and as president of the Natchez chapter of the NAACP. He said:

The Parchman Ordeal was very significant for us as individuals and for the black community. Many individuals who desired to help in the struggle could not because of who they worked for and feared retribution, even death. They could not care for their families. So with many young people willing to march for justice, freedom and equality on behalf of their parents and themselves, they were willing to suffer to the end.

Parents had encouraged their children that things would get better, so when the opportunity [arose] *to make a demonstration, they did. They put everything on the line. In the words of freedom fighter Fannie Lou Hamer, "I'm* [sick and] *tired of being sick and tired." The words of Patrick Henry rang loud: "Give me liberty or give me death."*

To the city of Natchez, a message was delivered to the white establishment in their face: there must be a change from business as usual. A new day has been coming for a long time. This was a beginning. It proved that black folk were not afraid of what white folk could do. We could fight back and hit them where it hurt the most: in the purse and pocketbook.

Ronald Coleman said:

They need to know that Natchez had a place in history. Natchez had some good, some bad things going on, but those are struggle years. People were killed. People that I know of that was killed, some physically damaged here. This all happened here in Natchez. I saw brutality. I saw people's houses get bricks thrown through it, windshields cracked, young teenagers fighting, black and white. We used to say Natchez is a great place to be from. When I say be from, I mean get out of here. It's changing. It's a beautiful place. It has a lot of history to it. I'm glad to be born here for that fact that I was born in a historical place. There's a lot of things that can grow from this. That's why I didn't mind telling my story as to how life has played a part in it for me here, so my kids can know there was a movement here.

We close with words from three wise men who played an integral role in the civil rights movement in Natchez, Mississippi, and the nation. We start with former governor William F. Winter, followed by civil rights leader Charles Evers and President Lyndon B. Johnson in his Voting Rights Act address to Congress in 1965.

William F. Winter:

Let me say the struggle for rights certainly ought to be over. We've been through enough, spent too much time battling, defending the indefensible. And by this time, there should not be any question but that anybody, any person regardless of race or social or economic standing, should be able to vote without being objected to, without being opposed, without being threatened.

I had hoped that the passage of the Voting Rights Act would eliminate those problems. Unfortunately, the struggle does not seem to be over. So the struggle is not over. We still have to work to maintain both the letter and the spirit of the Voting Rights Act of 1965 and not let anything discourage people from being able to vote and of not being threatened or intimidated in the process of trying to vote.

It is more important than ever that they vote and make sure that we don't slip back into those days when we let racial prejudice rule us. We owe it to those very brave men and women, black and white, who made it possible for the Voting Rights Act of 1965 to be passed, the Civil Rights Act of 1964 to be passed and to change the way that we live in the South. Now, this is a much better region than it was before. It's better because of the freedom that

has now been accorded people under the Constitution of the United States and enforced through the Voting Rights Act and the Civil Rights Act.

Charles Evers:

Over? No. It will never be over anymore. The struggle is our problem that we don't go out and vote like we should. The price that was paid by Medgar and Martin and our friends from Natchez was paid for us, this right to register and vote. It's a shame now, the way black folks do not use it. You know, in these predominantly black areas, many of them just don't even go to vote, let alone register.

President Lyndon B. Johnson:

The real hero of this struggle is the American Negro. His actions and protests, his courage to risk safety and even to risk his life, have awakened the conscience of this nation. His demonstrations have been designed to call attention to injustice, designed to provoke change, designed to stir reform.

He has called upon us to make good the promise of America, and who among us can say that we would have made the same progress were it not for his persistent bravery, and his faith in American democracy. For at the real heart of battle for equality is a deep-seeded belief in the democratic process. Equality depends not on the force of arms or tear gas but upon the force of moral right, not on recourse to violence but on respect for law and order. There have been many pressures upon your President and there will be others as the days come and go, but I pledge you tonight that we intend to fight this battle where it should be fought, in the courts, and in the Congress, and in the hearts of men.

Note: As this book was being prepared for publication, the authors requested that the Natchez City Court offer the Natchez civil rights advocates, especially those who survived imprisonment at Parchman, the chance to have their arrests for parading without a permit in October 1965 expunged from city records. Several arrestees accepted the offer, with many more still to be contacted. Thus, the process has begun to right a terrible civil rights injustice.

Of the hundreds of young civil and voting rights advocates who were arrested in October 1965, most were taken to local jails and were not brought to Parchman. Most of those who were jailed locally were let go within hours or the next day after a bond was posted for their release. None received the abuse that the Parchman Ordeal survivors experienced at the state penitentiary.

AUTHORS' REFLECTIONS

G. MARK LAFRANCIS

They say the Lord works in mysterious ways.

They are right.

This book never would have been produced without several key events happening seemingly as if a force was making them happen.

On Sunday, February 23, 2014, I lazed in my easy chair at home, relaxing after a hardworking weekend with the Natchez Literary and Cinema Celebration (NLCC), a magnificent multi-day event. The NLCC traditionally likes to theme its events, and that year civil rights dominated the lectures, programs and events. I worked behind the scenes helping with set-up, audio, graphics and such. So, my recliner that final day of the NLCC's civil rights weekend was a good place to sit back and relax and enjoy a successful celebration.

However, there was one last event, one that I had promised to attend but wished I could skip. It was an afternoon tour of churches—African American churches—that figured prominently in the civil rights struggle in Natchez. I tried to drift to nap, but guilt slapped me to reality.

So I drove to the area where the tour was to be held and saw almost no vehicles. It was, I thought, my sign of permission to go home, until a local historian, David Dreyer, walked by looking for the tour of churches. I told him I didn't think anyone wanted to go on the tour because of the nearly empty parking lot. But David urged me to walk with him. And so we did.

We arrived at a small but important church in the Natchez African American movement, as well as the civil rights era. It was Rose Hill Baptist Church. Inside, I heard of the agonizing struggle of African Americans in the 1960s and earlier to survive crushing segregation and humiliation. The church was packed with both blacks and whites, all riveted on the speakers. I felt somewhat ashamed that I had not appreciated or learned about these struggles and the deeply personal effect segregation, Jim Crow and Klan activity had on the African American community in which I live and work.

Next, we walked to Beulah Baptist Church, about a block and a half away. Beulah, like Rose Hill, is of similar construction: white facing, brick foundation and simple steeple. Inside, my world changed. There, among civil rights songs, intense preaching and many "amens," three folks talked about the time in 1965 when they were hauled to the Mississippi State Penitentiary in Parchman, where they were abused, humiliated and punished for days. They spoke of the time they wanted to march to support civil rights but were stopped outside that church by law enforcement, herded onto buses and taken to the Natchez City Auditorium. In all, there were hundreds—upward of seven hundred—taken to the auditorium (where, ironically, African Americans were not allowed to attend the dances, pageants and performances by whites).

As if that were not enough, about 150 of those young people—mostly in their teens and early twenties—were forced onto buses and brought to the Mississippi State Penitentiary in Parchman. Three now-older folks at Beulah Baptist Church that Sunday spoke briefly of that experience.

It was an astonishing experience that I thought, for sure, had been reported, chronicled and exposed. But sadly, I learned, these experiences existed in the hearts and minds of the survivors, whose numbers, of course, were diminishing almost weekly.

So there we have it: an incredible, untold moment in the national civil rights movement involving young men and women, as young as fourteen, being imprisoned for days and subjected to terrible abuse.

Our small but determined team, which includes Robert Morgan and Darrell White, embarked on an incredible journey with many of the survivors to tell and archive their stories through a grant from the Mississippi Humanities Council. Those interviews evolved into a documentary, *The Parchman Ordeal: The Untold Story*, which has received acclaim at film festivals and been aired on Mississippi Public Broadcasting. And now the stories, many at length, appear in this book.

My hope is that you have been inspired as I have been by the courage of the men and women who suffered needlessly.

ROBERT A. MORGAN

I am humbly grateful for the opportunity to participate as a team member in a project to unveil the pain and agony of the times for many strong individuals who paid a significant price, especially the youths, and to document their life-altering achievements. They've kept it locked away in their hearts in plain sight for fifty or more years.

We encountered many strong-willed participants who stood firm against inhumane brutality anchored by perceived race supremacy and political and economic dominance that shackled them to a life of inferiority. This experience demonstrates once more that the youth of each generation continue to rise to the demanding circumstances that confront them. They accepted the spiritual generational baton of youthful activism passed along in a time-immemorial march toward a more perfect union of safety and equality for all.

Their dominant theme was to do their part to make Natchez better for future generations. In the words of our co-author Darrell White, if Harlem is considered the site of New York City's Renaissance of intellectual, social and artistic explosion in the 1920s, then Natchez, Mississippi, can be considered the jewel of the South.

DARRELL S. WHITE

The producers of the documentary film *The Parchman Ordeal: The Untold Story* and authors of this book set out with one solid objective: to create a platform upon which the stories of those who were impacted would be recognized. Very few within the community had any knowledge of what had transpired so many years ago. It was hard for many to believe that anyone would be sent to the penitentiary for walking down the street. But it did happen.

It was time for the after-effects of Jim Crow and segregation to come to an end. The federal courts had ruled, but many southern states were unwilling to comply. The people stood up and spoke out to be recognized. It took courage to take a stand against injustice and to come forward and revisit what had happened so long ago in our interviews.

Throughout the nation, a movement was growing. I am reminded of the words of a popular song of that era that many found inspirational in this river city:

"Change Is Gonna Come"

I was born by the river in a little tent
Oh and just like the river I've been running ev'r since
It's been a long time, a long time coming
But I know a change gonna come, oh yes it will

It's been too hard living, but I'm afraid to die
'Cause I don't know what's up there, beyond the sky
It's been a long, a long time coming
But I know a change gonna come, oh yes it will

I go to the movie and I go downtown
Somebody keep tellin' me don't hang around
It's been a long, a long time coming
But I know a change gonna come, oh yes it will

Then I go to my brother
And I say brother help me please
But he winds up knockin' me
Back down on my knees, oh

There have been times that I thought I couldn't last for long
But now I think I'm able to carry on
It's been a long, a long time coming
But I know a change is gonna come, oh yes it will
—Sam Cooke

This project was a labor of love and respect by the team. What started only as an attempt to document oral histories for archival purposes developed into a film and now this book. Let the truth be told for all to hear. May you find enlightenment in the knowledge of the sacrifices made toward the betterment of this nation. Find the courage to make a change.

BIBLIOGRAPHY

Anderson, Aaron D. *Builders of a New South: Merchants, Capital, and the Remaking of Natchez, 1865–1914*. Jackson: University Press of Mississippi, 2013.

Boxley, Ser Seshs Ab Heter-C.M. *Forks of the Road Enslavement Market*. Pamphlet.

Evers, Charles, and Andrew Szanton. *The Charles Evers Story: Have No Fear: A Black Man's Fight for Respect in America*. New York: John Wiley & Sons Inc., 1997.

Ladd, Donna. *Evolution of a Man: Lifting the Hood in South Mississippi*. Jackson, MS: Jackson Free Press, 2011.

Library of Congress. *From Slavery to Freedom: The African-American Pamphlet Collection, 1824–1909*.

Mellon, James, ed. *Bullwhip Days: The Slaves Remember, an Oral History*. New York: Avon Books, 1988.

Nelson, Stanley. *Devils Walking: Klan Murders along the Mississippi in the 1960s*. Baton Rouge: Louisiana State University Press, 2016.

Oshinsky, David M. *Worse Than Slavery: Parchman Farm and the Ordeal of Jim Crow Justice*. New York: Simon & Schuster, 1996.

Pincus, Edward, and David Neuman. *Black Natchez*. The Center for Social Documentary Films, Cambridgeport Film Corp., 1966, and Amistad Research Center, Tulane University.

Reminiscences of an Active Life: The Autobiography of John Roy Lynch. Jackson: University of Mississippi Press, 2008.

Thompson, Julius E. *Lynchings in Mississippi: A History, 1865–1965*. Jefferson, NC: McFarland & Company Inc., 2007.

Umoja, Akinyele Omowale. *We Will Shoot Back: Armed Resistance in the Mississippi Freedom Movement*. New York: New York University Press, 2013.

Vollers, Maryanne. *Ghosts of Mississippi: The Murder of Medgar Evers, the Trials of Byron De La Beckwith, and the Haunting of the New South*. Boston: Little, Brown & Company, 1995.

Wood, Amy Louise. *Lynching and Spectacle: Witnessing Racial Violence in America, 1890–1940*. Chapel Hill: University of North Carolina Press, New Directions in Southern Study, 2009.

Yesko, Parker. *Letter from Parchman: Inside Mississippi's Notorious Prison*. St. Paul, MN: American Public Media, 2018.

INDEX

Parchman Ordeal authors and producers (*from left*) Darrell S. White, G. Mark LaFrancis and Robert A. Morgan.

ABOUT THE AUTHORS

G. MARK LAFRANCIS has been a writer and photographer for more than thirty years, mostly in journalism. He has won many local, state and national writing awards as a reporter, photographer and columnist. He was selected as the 2018 Mississippi Scholar by the Mississippi Humanities Council for his extensive work as an oral historian, teacher and filmmaker.

His credentials include editor, photographer and writer at daily and weekly newspapers; instructor of film and photography at secondary and post-secondary schools; private photographic consultant; graphic designer; and photo contest judge for various organizations. He is past president of the Mississippi Writers Guild.

He has been involved with filmmaking for twenty years. His most recent film, *The Parchman Ordeal: The Untold Story*, was created from an oral history project sponsored by the Mississippi Humanities Council. The documentary film has aired on Mississippi Public Broadcasting and won several film festival awards, including the prestigious Most Transformative Film at the 2017 Crossroads Film Festival. A related film and oral history project about women in the civil rights era is in pre-production with grants from the Mississippi Humanities Council and the Mississippi Film and Video Alliance. In 2009, Mark received the first Thad Cochran Humanities Achievement Award for his documentaries on Richard Wright and Eudora Welty.

He is a retiree of the Armed Forces, in which he served for twenty-three years in the U.S. Air Force, Air National Guard and Air Force Reserve. During his years of service, he earned two Air Force Commendation

Medals. He recently retired as director of public information at Copiah-Lincoln Community College's Natchez campus, where he worked for fifteen years. During his tenure, he created the Film and Broadcasting Program, the Institute for Young Film Makers and the Chocolate Milk Café, a writing and reading program for young authors.

He is an independent filmmaker and has taught a groundbreaking Introduction to Film and Photography course at Adams County Christian School, Natchez High School and the Fallin Career and Technology Center in Natchez, where he serves as an artist in residence.

For the past seven years, he has interviewed soldiers from Iraq and Afghanistan and their loved ones, letting them inspire a book collection and a multimedia program, which has been endorsed by the Mississippi Humanities Council and the Mississippi Arts Commission. There are more than seven hundred poems in the collection, with three books published already under the titles *In Their Boots: Poems Inspired by Soldiers and Their Loved Ones.* Mark also has published five books for young readers and has given his speaking program "Storytelling from My Front Porch" to many elementary schools.

Recently, Mark received several grant awards from the Mississippi Humanities Council for the Mississippi World War II Veteran Oral History Project, allowing him and interviewers to record the stories of World War II veterans. So far, he and his team have interviewed more than eighty veterans. Their stories will be preserved at the University of Southern Mississippi Center for Oral History and Cultural Heritage. Mark is the son of a World War II veteran and grandson of a World War I veteran. His previous oral histories include the "Flood of 2011" and the Natchez Literary and Cinema Celebration, where he has been a presenter multiple times.

He is the self-published author of eight books, five for young readers, and has mentored young writers for the past twenty years.

Mark also is the founder and president of Home with Heroes Foundation Inc., a private nonprofit organization dedicated to helping veterans and their families, especially those suffering from combat and near-combat experiences.

Mark lives in Natchez with his wife, Eileen. They have two grown children, Mark and Mary.

ROBERT A. MORGAN is a thirty-year U.S Air Force military veteran who lives in Natchez, Mississippi. Morgan has a diverse background in operational

maintenance and strategic planning. Over the years, he used administrative experiences to contribute to the documentation of historical events leading to increased awareness of previously underreported events. His background includes project management, with video recording as a hobby.

He is a hands-on leader with sound people skills and a strong background working with individuals from all walks of life.

Morgan holds a master's degree in human resources management from Troy State University and an undergraduate degree in business management from St. Leo College. In his spare time, Morgan enjoys gardening and do-it-yourself work with his wife, Lou.

He was co-producer of the award-winning documentary *The Parchman Ordeal: The Untold Story* and is co-producer for the upcoming film *Women of the Struggle: Facing Fear in the Civil Rights Era*. He works in partnership with New Dawn Video Productions and the Natchez Association for the Preservation of Afro-American History and Culture.

DARRELL S. WHITE of Natchez is director of cultural tourism for the City of Natchez, as well as director of the Natchez Museum of African American History and Culture. He is widely recognized as an authority on African American history in the Natchez region and has contributed to many publications, pamphlets, reenactments and programs about African Americans.

He is a former counselor and assistant band director for the Natchez-Adams School District and former account executive and broadcaster for the Natchez Broadcasting Company.

White has served as executive director for the Natchez chapter of the American Red Cross and as assistant supervisor for the City of Natchez Office of Tourism Management.

He is a native of New York, where he grew up and attended schools.

He was co-producer and narrator of the award-winning documentary *The Parchman Ordeal: The Untold Story* and is co-producer for the upcoming film *Women of the Struggle: Facing Fear in the Civil Rights Era*. He works in partnership with New Dawn Video Productions and the Natchez Association for the Preservation of Afro-American History and Culture.